BEN NICHOLSON

JEREMY LEWISON

BEN NICHOLSON

RIZZOLI
NEW YORK

Acknowledgements
*I am particularly grateful to Serge Fauchereau who
suggested I should write this book and to Richard
Morphet for reading the text and making many useful
suggestions. Permission to reproduce the works has
kindly been granted by Angela Verren Taunt, the
copyright holder.*

*This book is dedicated to my parents who first
introduced me to the work of Ben Nicholson.*

*The format of the title of each work follows the
preferred style of Ben Nicholson which he adopted from
the mid thirties onwards.*

First published in the United States of America in 1991 by

RIZZOLI INTERNATIONAL PUBLICATIONS, INC.
300 Park Avenue South, New York, NY 10010

Library of Congress Cataloging-in-Publication Data

Lewison, Jeremy,
 Ben Nicholson / Jeremy Lewison
 p. cm.
 Includes bibliographical references.
 ISBN 0-8478-1395-9
 1. Nicholson, Ben, 1894- —Catalogs. I. Nicholson, Ben, 1894-
II. Title.
ND497.N58A4 1991 91-11556
759.2—dc20 CIP

Color separations by Reprocolor Llovet, S. A., Barcelona
Printed and bound by La Polígrafa, S. A.
Parets del Vallès (Barcelona)
Dep. Leg. B. 15.505 - 1991 (Printed in Spain)

CONTENTS

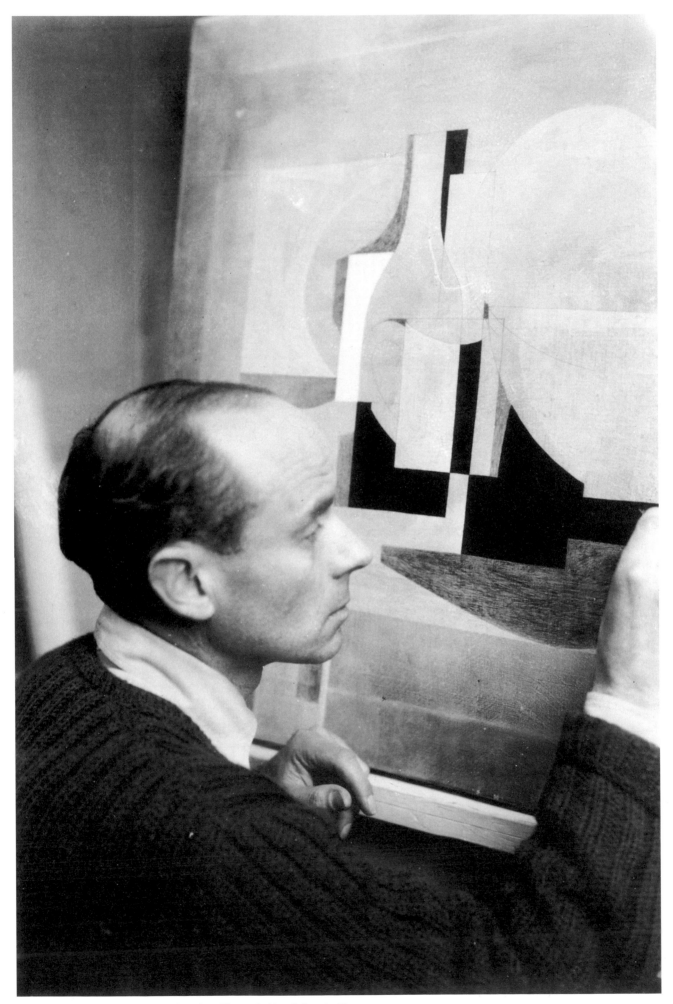

The artist at work. *c.* 1935. Photograph Barbara Hepworth. Tate Gallery Archive.

BEN NICHOLSON

Early years

Ben Nicholson was born in the last decade of the reign of Queen Victoria on 10 April 1894. The Victorian era was particularly important in the history of British art beginning with late Constable and Turner, succeeded by the Pre-Raphaelites, William Morris and the Arts and Crafts movement and finally the beginnings of the illustrious career of Walter Richard Sickert. By the time that Ben Nicholson embarked on his career as an artist, however, the British art scene had undergone a remarkable convulsion which divided the art world and which was to stimulate him into seeking to rebel against the traditions of Victorian and Edwardian painting. By then the challenging theorists were Roger Fry and Clive Bell who, through the organisation of exhibitions, the delivery of lectures and the publication of books, changed the direction of the British avant-garde.

Ben Nicholson was the eldest son of William Nicholson and Mabel Pryde. He was educated principally in London and left school at the age of sixteen to attend the Slade School of Fine Art. His father William was a successful portraitist, as well as a considerable painter of landscape and still life. He was described by Ben Nicholson as 'very lively and elegant... dandified but always with a very special taste of his own and he alternated this with looking like a tramp.' As a painter of members of high society he mixed with affluent people but his own lifestyle was rather more bohemian.

Together with James Pryde, his brother-in-law, he formed 'J. & W. Beggarstaff' designing posters which Ben Nicholson regarded as 'a complete revolution in their time (1893)' (all quotes from 'William Nicholson' in M. de Sausmarez (ed.), *Ben Nicholson*, London 1969). These graphic works were dramatic, with broad flat forms and an economic use of stencilled colour, and incorporated lettering as an integral part of the design, a feature which would not be lost on Ben Nicholson in later years. His mother, Mabel Pryde, was also a painter, although after the birth of her children she had little time to develop her talent.

The Nicholsons had a wide circle of friends including William Orpen, Max Beerbohm and Sickert as well as strong links with the theatrical and literary world. William published a series of books with colour woodcuts under the Heinemann imprint and in 1900 he was awarded a gold medal for his woodcuts at the Exposi-

tion Universelle in Paris. From this moment on, however, he turned back to painting.

Apparently untouched by the critical debates of the second decade of the century, William Nicholson certainly would have been aware of them, just as he would have been acquainted with the artists and critics who were associated with Bloomsbury. More important for Ben, however, was that he came from a family of painters and that his father was playful in life but direct in his approach to painting. Ben Nicholson attended the Slade School of Fine Art in 1910, the same year that Roger Fry mounted 'Manet and the Post-Impressionists', the exhibition in which he introduced Post-Impressionist painting to London, particularly Cézanne, Gauguin and van Gogh. Matisse, Derain and Picasso were also represented but only one of the latter's paintings in this exhibition gave a hint of what he was exploring at this time. Fry's 'Second Post Impressionist Exhibition' of 1912 was more radical in its introduction of Fauvism and Cubism which he combined with the more avant-garde aspects of British art, notably the work of Duncan Grant and Wyndham Lewis, selected by the critic Clive Bell. Nicholson may have seen the first of these exhibitions but he would have missed the second of them, since he spent much of the time between the end of 1911 and 1913 abroad learning foreign languages.

His attendance at the Slade lasted only three and a half terms. His short stay was the result not only of his impatience with the academic manner of teaching under Professor Henry Tonks but also a lack of conviction that he wished to pursue an artistic career. Indeed he had given some consideration to becoming a writer. Nicholson relates how he spent most of his time at the Slade playing billiards with Paul Nash in the nearby Gower Hotel. He stated some thirty years later that Nash 'was much more serious than I was — I was in the painting world and trying to get out and he was out and trying to get in' (letter to John Summerson 6 May 1944). Judging by the earliest of his paintings which survive, he was untouched by his experience at the Slade but was more influenced by the painting of his father.

The earliest known paintings by Nicholson were made in a manner typical of traditional Edwardian painters and were principally still lifes, although he also painted portraits, such as *1917 (portrait of Edie)*, which has a clarity of form and light which anticipates the

A house in Castagnola, Lugano. Photograph Ben Nicholson.

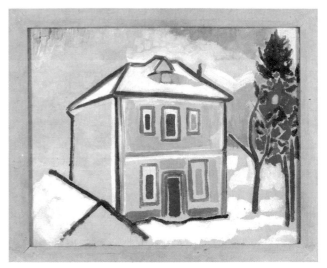

c. 1921 (pink house in the snow). Oil on canvas, 18 ⅛ × 22 in. (46 × 56 cm). Private collection.

post-war work of artists such as Wyndham Lewis. Nicholson has acknowledged his debt to his father stating that he owed much to him,

> especially to his poetic idea and to his still-life theme. That didn't come from Cubism, as some people think, but from my father — not only from what he did as a painter but from the very beautiful striped and spotted jugs and mugs and goblets, and octagonal and hexagonal glass objects which he collected. Having those things throughout the house was an unforgettable early experience for me. (*Sunday Times,* 28 April 1963)

Nicholson pursued his father's interest in collecting such objects and these were to provide him with source material throughout his long career but, whereas in his later works they were a starting off point for imaginative compositions, in his earliest works, such as *1919 (blue bowl in shadow),* the depiction was more or less faithful. In the earliest paintings the treatment of the still life objets is polished and realistic with an emphasis on light, reflections and materials. *1919 (blue bowl in shadow)* is perhaps the closest Nicholson came to his father's style in mood and execution. The use of white pigment to punctuate dark areas of paint with flashes of light was also an inherited trait, as was the intense focus on the single object. Even the composition itself may owe a debt to his father since by 1918 William Nicholson's still lifes had become more informal, the subjects being placed at slightly unusual angles in a shallower space.

In retrospect Ben Nicholson regarded these works as 'slick and "Vermeer"' (letter to John Summerson, 3 January 1944) and he made a conscious effort to change his manner of painting. The shortening of his signature from Benjamin to Ben Nicholson around 1920 was symptomatic of his desire to relinquish a traditional approach to painting and to abandon a polished style for one which was more workmanlike and modern. Marriage to Winifred Roberts in the same year was an added stimulus, since she too was a painter struggling to find an idiom which would lead her away from the Pre-Raphaelite style she had affected in the preceding years. Winifred had already adopted the practice of painting outdoors and had discovered the space creating properties of colour while spending some time sketching and painting in India. It was she who encouraged Nicholson to paint outside and to lighten his palette from the murky gloom of his studio-bound paintings. Spending their honeymoon in Venice, Florence, Rome, Pisa, Naples, Lugano, Portofino and Genoa also gave them ample opportunity to absorb the achievements of Italian painting, which was to have a considerable impact on their art in the next few years.

The twenties

In the early twenties the Nicholsons were based in Cumberland and London, where they rented a flat off the King's Road, Chelsea. In 1920 they purchased Villa Capriccio at Castagnola above Lake Lugano with money provided by Winifred's father. Dividing their time between Cumberland, Chelsea and Switzerland, Ben and Winifred explored at great pace and with intense concentration the art of painting still life and landscape, experimenting with various styles from the primitive to the Cubist. Nicholson painted an average of two paintings a day, although few canvases from this period survive, since he destroyed many with which he was dissatisfied or simply painted over them. But it was what he called 'a very important period of fast and furious experiment' (letter to John Summerson 4 January 194[?]4). Many of his paintings were executed outside in the snow, a practice which appalled David Bomberg who visited the Nicholsons in Switzerland in 1922, but which served to lighten Nicholson's palette and made him aware of the brightness of light.

The colours of *c. 1921 (pink house in the snow)* indicate a possible Fauve influence at this time although the crudeness of the drawing suggests a return to child-

like imagery. This latter aspect was symptomatic of his desire to move away from the sophisticated technique he had developed towards the end of the previous decade and which he ultimately found sterile. He had previously had contact with Vorticism, possibly as early as 1917, although he never participated in the movement itself which had reached its height in 1914. He may have been encouraged in looking at Vorticism by the Group X exhibition held in 1920, which marked the death throes of the movement and, in particular, by his friend Frank Dobson who was one of the sculptors in this short-lived exhibiting group. Nicholson's brief interest in Vorticism should be seen as little more than a desire to break with the tradition of painting associated with his family. None of his Vorticist works survive for he subsequently destroyed them. Vorticism had been a movement of aggression which in the aftermath of war seemed both irrelevant and distasteful.

Of far more interest to both Ben and Winifred were developments taking place in Paris, which they visited on their journey to and from Switzerland each winter (Nicholson continued to visit Paris on occasions in the later twenties). There they looked at works by Matisse, Picasso and Braque, African sculpture and the Italian primitives in the Louvre. They were also able to see exhibitions in museums, public galleries and dealers' galleries and could view the whole range of recent French art from Cézanne to those artists associated with the *rappel à l'ordre*. Nicholson was an avowed admirer of Cézanne and his influence is obvious in *1921–c. 1923 (Cortivallo, Lugano),* in which landscape and sky are merged and colour is laid down in patches with a stress on the material nature of paint. In addition, the depiction of the houses as cubistic blocks is highly reminiscent of Cézanne's handling of such motifs. The cool range of colours, however, in addition to being appropriate to a painting of a Swiss snow scene, may derive from Nicholson's interest in the paintings of the Italian Primitives, particularly Piero della Francesca whose clear, delicate blues and restrained use of deep tones must have made an impression on him both in reproduction and on his visits to museums in Paris and Italy. In a scrapbook of photographs he assembled in this period he included works by Giotto, Uccello, Cézanne, Rousseau, Picasso, Matisse, Braque and Derain, thereby demonstrating an interest in a wide range of art, nevertheless united by simplified and concentrated design and a tendency towards classicisation. It was these aspects which Nicholson was intent on exploring in his period of experiment.

If *1921–c. 1923 (Cortivallo, Lugano)* owes a debt to Cézanne it also manifests many of the characteristics which Nicholson was to develop more thoroughly in the next ten years: the scraping and weathering of the paint surface which emphasises its physicality; the sensitive and forceful use of line to leap across distance and time conjoining objects in the foreground and background; the employment of sharp accents of colour to punctuate larger tonal areas; the shallow depth and the desire to make incisions into the surface

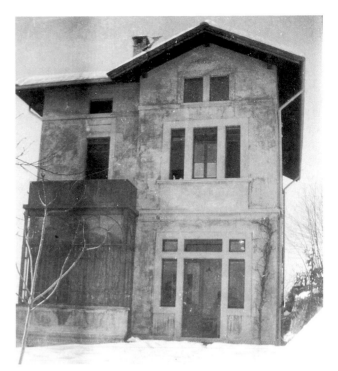

Villa Capriccio, Castagnola, Lugano.

of the paint to create real, as opposed to illusionistic, depth.

Nicholson's interest in landscape and still life, in themselves traditional subjects, was entirely consistent with modernist painting which employed these genres as vehicles for artistic experiment. They not only formed the principal subjects of Cubism but still life was enjoying a resurgence in the aftermath of World War One both in the art based around *L'Esprit nouveau,* the magazine edited by Ozenfant and Jeanneret, and in the continuation of the classical tradition. Nicholson's experimentation with it was partly a manifestation of his desire to be associated with the avant-garde. However, he also claimed that the still life theme came from his father. It was therefore a familiar vehicle which would provide a disciplined framework within which he could work.

The classicised image is found in *c. 1922 (Balearic Isles)* in which he tackles the female nude in a manner reminiscent not only of Cézanne but also, more relevantly, of Picasso who by 1920 was painting substantial, simplified classical figures often located by the sea. The portrait of Bertha *c.1923–24* is another example of his response to the resurgence of classicism. With one or two exceptions, however, he would not return to the figure again until 1932.

Among the most 'advanced' of his paintings of this period were *1924 (trout)* and *1924 (first abstract painting, Chelsea)* in which Nicholson indicates that he was aware of and had fully absorbed the synthetic Cubist manner of painting, as well as possibly the *papiers déchirés* of Jean Arp. Later in his life he recalled having seen a painting by Picasso, in a style similar to *Man Leaning on a Table,* 1915–16, at Paul Rosenberg's

gallery in Paris. In 1948 he stated in a letter to his brother-in-law John Summerson, the architectural historian who at the time was engaged in preparing a book on Nicholson, that the sighting of this picture was

the real revelation... It was what seemed to me then completely abstract and in the centre there was an absolutely miraculous green — v. deep, v. potent and absolutely real — in fact none of the events in one's life have been more real than that — and it still remains the standard by which I judge any reality in my work. It was this painting in among all the other exciting ptgs I saw in Paris 1921–22–23 that were such an inspiration. (3 January 1948)

This statement was written at a time when Nicholson was keen to emphasise the abstract nature of his art at the expense of his figurative works but, undoubtedly, a synthetic Cubist painting would have appeared abstract to someone brought up on a diet of Edwardian painting in Britain. It should not be forgotten, however, that the concept of abstraction in Britain in the early twenties was not defined by non-referentiality but by the distortion of natural appearance. Both paintings still relate closely to the still life theme, the striped section in *1924 (trout)* in particular recalling a painting (now destroyed) of a striped jug which Nicholson claimed he executed while still at the Slade. The organisation of rectangles is similar to the organisation of still life objects on a table, the shadow cast towards the top left indicating an illusion of solidity and depth.

Although these paintings maintained references to objects, the critics at the time considered them as patterns. British art and criticism in this period, with a few exceptions, lacked a detailed understanding of or interest in modern developments abroad beyond analytical Cubism and it must have been dispiriting for a young artist to encounter such misunderstanding of experimentation. Nevertheless, however grounded in still life these two paintings were, they verged on non-referentiality. It seems clear now that, together with any other similar works of this period (and only one further such work is known to exist), they were something of a formal exercise in highly abstracted still life and a development from previous works. What has been regarded as a return to still life and landscape should really be seen as just a continuation of a theme which Nicholson never abandoned.

The twenties saw the development of these themes in a manner which incorporated the lessons of synthetic Cubism with Nicholson's understanding of the paintings of Cézanne. *1924 (goblet and two pears)* is typical of the still lifes of the mid twenties in which the object is distorted in a Cézannesque manner. In addition the paint is thinly applied in broad and loose brush strokes, creating patches of saturated colour which are descriptive both of objects and of themselves, thereby displaying the application of a style of painting derived from his understanding of synthetic Cubism. The pencil line describing the outline of the pears does not coincide with the limits of the pigment, thus according the latter independence as a flat area of paint. The relationship of the objects to each other is not defined by spatial recession but by an adjustment of relative scale since, as in Cubist paintings, the space is very shallow. The flattening of space and the 'naïvety' of Nicholson's work in this period — for example in *1927 (still life with knife and lemon)* — was a source of objection among the critics of Nicholson's painting but naïvety, or deliberate simplicity and apparent lack of sophistication, were characteristics of the new painting by many young British artists at the time, who were searching for directness and naturalness of expression. In their efforts to embrace these characteristics these artists were of course anything but naïve and showed a knowledgeable understanding of the conventions of painting and drawing.

Nicholson's interest in naïvety can be traced back to his first rejection of Edwardian painting, in his desire to return to basics and to rid himself of the slick skills he had acquired both through parental inheritance and through his brief art school training. His interest in the Italian Primitives and in painters such as the Douanier Rousseau, whose work was the subject of an exhibition at the Lefevre Gallery, London in 1926, together with the prevailing interest in children's art, were all manifestations of a search for sincerity and directness in art and for an innocent perception. Such ideas were espoused by Clive Bell in his seminal book *Art*, first published in 1914, which was reprinted in England seven times between 1914 and 1930. Bell's theories must have been well known to Nicholson in spite of his insistence that he had little interest in theory. For a young painter seeking to establish himself and looking for

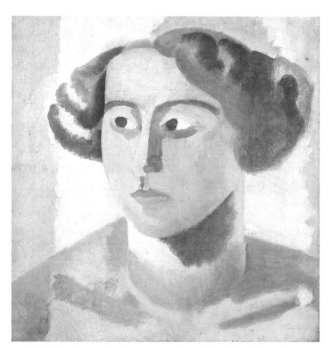

c. 1923-4 (Bertha no. 2). Oil on canvas, 24 × 22 in. (61 × 55.8 cm). Kettle's Yard, University of Cambridge.

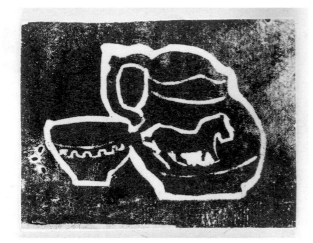

1928 (Jug and Bowl). Linocut, 2¾ × 3¾ in. (7 × 9.5 cm.).
Kettle's Yard, University of Cambridge.

a modern way in which to paint, such a book must have provided many valuable points of discussion. Bell defined abstract painting as one which rejected 'photographic naturalism' and favoured the distortion of the object to capture what he called the 'ultimate reality', divorced from the associations of life. The perception of such forms gave rise to 'aesthetic emotion'. Bell's theories, influenced and partially shared by Roger Fry, had a considerable impact on art in Britain in this period, not only as manifested in the writing of contemporary critics but also in actual production of works of art. A painting such as *1924 (goblet and two pears)* could easily be accommodated within the framework of Bell's theories.

Nicholson's wilful 'naïvety', as evidenced in *1924 (goblet and two pears)* and many other paintings of the late twenties, reached its fullest expression in 1928 in a work such as *1928 (Walton Wood cottage no. 1)*, where he combines a romantically naïve vision of domesticated nature with a mature appropriation of the forms of synthetic Cubism. The desire to achieve flatness, to stress the reality of the picture surface as a two-dimensional object, is compatible both with innocent perception prior to adjustment by the brain and with the prevailing sculptural interest in remaining truthful to materials. Just as sculptors such as Henry Moore and Barbara Hepworth wished to retain in their work a strong sense of the origins and nature of the materials they were using, so Nicholson stressed the process of the formation of the picture and its two-dimensionality. This is already noticeable in an early work, *1923 (Dymchurch)*, painted in Sussex while staying with Paul Nash, in which Nicholson emphasised the flatness of the painting by facing straight out to sea, the line of the breakwater paralleling that of the frame. He stressed the material nature of the paint by painting over a deliberately roughened ground so that marks made in the priming process would unavoidably be retained and impose themselves on any subsequent repainting. The idea of stressing the materiality of the paint surface was to be further developed in the reliefs

of the early thirties and again much later in Nicholson's career.

In the works made before 1928, marks made in the priming process are generally perceived only through a veil of pigment applied in later coats. In *1928 (Pill Creek)* Nicholson scraped away at the paint surface to exploit and retain the brightness of the gesso ground beneath, breaking through the former to penetrate the underpainting and create a minimal but actual physical depth. According to Winifred Nicholson it was Christopher Wood's idea to paint on a gesso ground, Wood having spent the summer of 1928 painting with the Nicholsons in Cornwall. Indeed in terms of surface texture Nicholson's and Wood's paintings of 1928–30 show a similar interest in stressing materials. They also show a remarkably similar graphic style.

It was during that summer that Nicholson and Wood discovered the fisherman painter Alfred Wallis living in St. Ives, Cornwall. Wallis had retired from deep sea fishing and at the age of seventy, upon the death of his wife, had taken up painting to keep himself company. His unaffected paintings of fishing boats and landscapes appealed to Nicholson on account of their fresh and child-like vision, but Nicholson also valued Wallis's use of irregular pieces of cardboard on which to paint and the interrelationship he achieved between ground, texture and colours. Nicholson perceived in Wallis's work a sense of the painting as an object and enjoyed the stress he placed naturally and possibly unknowingly on materials.

From 1928–30 Nicholson painted a series of 'naïve' landscapes and seascapes such as *1928 (Pill Creek)*, *1928 (Porthmeor Beach, St Ives)* and *1929 (Holmhead, Cumberland)* which are suggestive of directness, expressiveness and innocence, while at the same time showing considerable thoughtful reworking. The trees in a painting such as *1929 (Holmhead, Cumberland)* recall the work of van Gogh in their anthropomorphic nature (a characteristic also of Wood's paintings at this time), whereas the depiction of the horse can be associated with the art of children. The weathered texture is typical of Nicholson's paintings in this period and is also to be found in the contemporary paintings of the Frenchman, Jean Fautrier.

Although there is no evidence as yet that Nicholson knew the work of Fautrier at first hand, an examination of the work of both artists towards the end of the twenties reveals striking similarities. Both painted still lifes in umber tones, both enjoyed a highly textured surface in which the paint was constantly scraped back and incised and both painted in a manner informed but not dominated by Cubism. While undoubtedly Georges Braque was a major influence on Nicholson's work, particularly his *Guéridon* series, Nicholson was more catholic in his interests than might previously have been thought. A painting such as *1927 (still life with fruit)* recalls Fautrier's *Nature morte au raisins* of the same year (collection Montenay, Paris) while Fautrier's *Les Poires*, 1927 (collection Seibel, Bonn) is highly reminiscent of Nicholson's earlier *1924 (goblet and two pears)*

11

not only in colour but also in the manner in which the incised outline of the pears does not coincide with the infill. Fautrier first exhibited in Paris at Galerie Visconti in 1924 and held a second exhibition in 1925 at Galerie Fabre. He was also included in a mixed show at Zborowsky's gallery in the company of Modigliani, Kisling and Soutine. It is possible, therefore, that there may have been some kind of exchange of ideas.

Braque, however, was of greater importance for the composition of Nicholson's still lifes in this period. The table-top still life was a consistent theme in Braque's work, painted generally in subdued tones with considerable emphasis on earth colours. The overlapping objects found in Nicholson's work of the late twenties together with the flattened perspective are characteristic of Braque but, whereas Braque was interested in the plasticity and merging of objects, Nicholson emphasised their flatness, independence and individuality. In *1927 (still life with knife and lemon)* the weight of the jug enforces a change in contour of the plate, the right side of the plate suffering an indentation to accommodate the bulge of the pitcher. Generally speaking Nicholson's compositions were less complex, placing greater emphasis on the individual characteristics of the objects, for example the sweep of a jug handle or the pattern on a mug. Braque's paintings were still dominated by an allegiance to Cubism whereas Nicholson had been born a decade too late to participate in this movement. While accepting the changes in the perception of the object which Cubism introduced, Nicholson was less interested in Cubist structure. In *1927 (still life with knife and lemon)* he isolates the objects and whereas in a Cubist composition each object would be seen from different angles, here each object is viewed from a single angle, although not consistently the same one. Thus the jug is portrayed in profile while the plate is seen from above.

The twenties was a decade of artistic variety and experiment for Nicholson in which he continued to educate himself by appropriating and assimilating the styles of other artists, using them, however, in a manner which was ultimately characteristic of no one but himself. His paintings in this decade show evidence of a mastery of line, a quick and incisive wit, an ability to paint in close tones rather than high pitched colour and, above all, an enjoyment of materials. It was a decade in which he established friendships with many of the younger British artists who looked towards the Continent for direction, among them Paul Nash, Ivon Hitchens, Frank Dobson and Christopher Wood, and it was a period in which he began to exert a growing influence over the course of British art. Supported by the nomination of Ivon Hitchens, in 1924 he had become a member of the Seven and Five Society which was an alternative exhibiting society to, for example, the New English Art Club or the London Group with which Nicholson had exhibited an abstract painting entitled *Andrew* in the same year. While the Seven and Five had a varied membership of artists, still life and landscape were the predominant subjects. By 1926

Nicholson had become president of the society and this office became the power base from which he would successfully promote the modernist cause in British art.

The thirties

The thirties started auspiciously with Nicholson's first exhibition in Paris, jointly held with Christopher Wood and Winifred Nicholson at the Galerie Georges Bernheim, and his second ever one-man exhibition, held at the Lefevre Gallery, London. His first solo exhibition had been at the Adelphi Gallery in 1924, the six year gap indicating the degree of difficulty facing a young artist in Britain in becoming established. In the intervening years Nicholson exhibited in a number of group exhibitions and had been noticed by the critics, sometimes favourably and sometimes scornfully, but by 1930 he was clearly recognised as one of the prominent artists of the younger generation. The exhibition in Paris was barely noticed save for a small review in *Cahiers d'Art* but it provided an excuse for an extended visit to Paris with Winifred and their two children Jake and Kate. In July 1931 a third child, Andrew, was born at Bankshead, a farmhouse built on a mile-castle on Hadrian's Wall which the Nicholsons had acquired in 1924. However, by August that year the marriage was under strain, Ben Nicholson moving to London largely because he found the isolation of living in the north of England detrimental to his career.

In 1931 he met the sculptor Barbara Hepworth. He may possibly have seen the exhibition she held in 1930 with her husband, the sculptor John Skeaping, but in April 1931 Nicholson and Hepworth exhibited together with the potter William Staite Murray at the Bloomsbury Gallery. At Easter 1932 they travelled to France visiting the studios of Arp and Brancusi on route to Provence, returning via Gisors to visit Picasso at the Château Boisgeloup. Back in France in the summer they met Calder, Giacometti and Miró in Paris and spent some time with Braque in Dieppe. All these artists were known to Nicholson and it was he who introduced them to Hepworth, who became particularly interested in Arp, Giacometti and Brancusi. For Nicholson the most important contacts were Picasso, Braque, Miró and Calder. By 1932 he and Hepworth had begun to share a studio in Hampstead, an area of London in which many of the leading young artists and critics lived including Henry Moore, Paul Nash, Herbert Read and H.S. Ede (then working at the Tate Gallery and who later gave his collection, now known as Kettle's Yard, to the University of Cambridge). Discussion and debate flourished in this climate.

The relationship with Hepworth marked the beginning of a new and fruitful phase of Nicholson's art. The pleasure he experienced in this appears to have led him to paint subjects including overtly biographical elements such as the rendering of the head of Barbara Hepworth, sometimes merging with his own. Examples of these are seen in *1932 (profile - Venetian red), 1932*

(prince and princess), 1932 (Au Chat Botté) and 1933 (St. Rémy, Provence) among others. This practice did not last beyond a year and had precedents in earlier paintings such as the portrait of Winifred and Jake painted in about 1927, but it provides clear evidence of the impact on his life of his new circumstances. Not that Nicholson lost contact with Winifred who towards the end of 1932 had moved to Paris. Indeed, although their relationship was to be somewhat strained in the first few months, they were to keep in close touch by prolific correspondence and through the trips Ben made to Paris to visit her and the children.

The paintings of 1932 were still predominantly still lifes but 1933 (St Rémy, Provence), painted the following year, lies outside this category. While clearly reminiscent of the Boisgeloup paintings of Picasso in its treatment of the figure in a classical manner, the painting displays the fluency of line which was so characteristic of Nicholson's mature painting and, in the superimposition of faces with Miroesque target eyes, sees the beginning of Nicholson's interest in Surrealism. 1932 (Au Chat Botté) is perhaps the closest of all Nicholson's paintings to a composition by Picasso, although it is frequently compared with Braque's Café Bar, 1919 (Kunstmuseum, Basle), in view of the appearance in the apparent foreground of both paintings of writing on a window. However, a closer source is Picasso's Buste, compotier, mandoline, tapis rouge, 1924 (private collection) which consists of a still life on a table top comprising similar elements disposed in a roughly similar way. The importance of 1932 (Au Chat Botté), however, was not in the homage paid to Picasso and Braque but in the manner in which Nicholson was beginning to organise space within the picture. While he may not have been aware of the future importance of his new departure at the time, in 1941 he recognised this painting as having been a key work:

> About space-construction: I can explain one aspect of this by an early painting I made of a shop window in Dieppe though, at the time, this was not made with any conscious idea of space but merely using the shop-window as a theme on which to base an imaginative idea. The name of the shop was 'Au Chat Botté', and this set going a train of thought connected with the fairy tales of my childhood and, being in French, and my French being a little mysterious, the words themselves also had an abstract quality — but what was important was that the name was printed in very lovely red lettering on the glass window — giving one plane — and in this window were reflections of what was behind me as I looked in giving a second plane — while through the window objects on a table were performing a kind of ballet and forming the 'eye' or life-point of the painting — giving a third plane. These three planes and all their subsidiary planes were interchangeable so that you could not tell which was real and which unreal, what was reflected and what unreflected, and this created, as I see now, some kind of space or imaginative world in which one could live. ('Notes on Abstract Art', Horizon, vol. 4, October 1941.)

The head is Hepworth's reflected in the window but it appears to be resting on the table. The jug in the foreground, which could only be inside the shop, appears to be outside since its contours obscure some of the lettering. A pentimento displaying a guitar at the bottom right adds an element of mystery to this painting of drifting objects. The merging of planes and the conjunction of flatness with shallow space recalls 1924 (trout) with its cast shadow and indicates that, after almost a decade of self-education, Nicholson had assimilated the lessons of Cubism and achieved a highly developed personal style. This complex rendering of pictorial space was anticipated in 1930 (Christmas night), a work which suggests an interest in Matisse not only in the use of the mirror but in the fluid nature of the paint. The mirror, the room and the view through the window are situated in different planes and it is possible to pass from the nearest plane (the room) to the furthest plane (the landscape) without passing through the intermediate plane (the mirror). Although the planes are not merged as in 1932 (Au Chat Botté) the germs of the idea are here.

Nicholson's use of lettering in 1932 (Au Chat Botté) was not unique to this painting. While possibly remembering the posters of the Beggarstaff Bros, he would have seen its use more recently in Cubist paintings as a device to suggest flatness and narrative content of a direct but wide ranging kind. Nicholson employs it in a number of other works of this year including 1932 (Auberge de la Sôle Dieppoise) and 1932 (Le Quotidien), which in its depiction of a newspaper comes close to standard Cubist iconography. The misspelling of 'revendiqe' (sic) in the latter and the dislocation of the 'se' of 'Dieppoise' in the former are typical of Nicholson's playfulness, a characteristic manifested in his work throughout his career not only by the witty characterisations and juxtapositions of objects but also by his titles and by the inclusion of playing cards, flags, animals, bus tickets, fireworks and so forth which populate his paintings. Nicholson had a passion for playing games, particularly tennis, the rhythms of which he likened to the rhythms and balances of a painting, especially an abstract one.

Although in retrospect it is possible to trace the ideas of the first reliefs back to the handling of space in 1932 (Au Chat Botté), it was far from clear at the time that this was the direction in which Nicholson was travelling. In parallel with such legible still lifes he painted others which were considerably more abstract and incorporated elements normally associated with Surrealism. In 1932 (painting) only the ghostly appearance of a table-top and two vertical bands representing legs prevent the painting from being completely abstract and the incisions into the surface, possibly depicting a nude, appear to be made in the gestural manner associated with automatism. In 1933 (milk and plain chocolate), which combines Miroesque or Calderesque discs with a cubistic bottle and a totally abstract background, there was further evidence that Nicholson was hovering between the abstractionist and Surrealist camps. 1933 (composition in black and white), with its vestigial

reference to a table and a guitar as well as a female nude, contains a similar ambiguity of allegiance.

Nicholson's position at this time was an accurate barometer of the state of the avant-garde in English art. In 1933 Paul Nash brought together a group of artists and architects who collectively formed Unit One. It held one exhibition which opened at the Mayor Gallery in April 1934 (and subsequently toured) and published an accompanying book with an introduction by Herbert Read and statements by the artists and architects together with photographs of themselves and their work. The members were Paul Nash, Ben Nicholson, Barbara Hepworth, Edward Wadsworth, Edward Burra, John Bigge, John Armstrong, Tristram Hillier and the architects Wells Coates and Colin Lucas. In an article in the *Listener* Paul Nash indicated that the members were 'separated from the main trend of contemporary English art', by being avant-garde, but were 'somehow allied in purpose'. In making such a statement Nash acknowledged the tangential position of modernist artists in relation to the contemporary taste for Post-impressionist English art and he suggested that the changes which had actually taken place within art practice — the move away from what he called 'Post-Cézannism and Derainism' — should now be recognised as 'the contemporary spirit'. He diagnosed 'a desire to find again some adventure in art' among sculptors, painters and architects who, broadly speaking, could be divided into two camps, those who pursued 'form' and those who pursued 'the soul', and these two polarities, as they were presented, encapsulated the biomorphic abstraction found in the work of some of the members of Unit One. Nicholson himself displayed both aspects in his work as did Nash and Wadsworth. Hillier, Armstrong and Burra were of a more Surrealist persuasion, Hillier being characterised by Nicholson with some disdain as 'a sort

of Pre-Raphaelite' (letter to Winifred Nicholson, 12 April 1934).

By the time of the Unit One exhibition differences between the members were already apparent and it was no surprise that the group soon disbanded. Between the moment of its formation and the date of the exhibition Nicholson had made his first non-referential reliefs and outwardly had little time any longer for Surrealism. Nash, on the other hand, was moving closer to De Chirico while Moore sought a synthesis of the two styles. Adherents to Surrealism and abstraction were by then in open conflict. Furthermore Nash, who had been the driving force behind the organisation of Unit One, had been seriously ill in 1933 and was abroad in the first half of 1934.

In retrospect, Nicholson's move into making reliefs appears to have been a fairly logical step. The space depicted within his paintings was becoming increasingly shallow to the point of flatness, as in *1933 (composition in black and white)* and *1933 (milk and plain chocolate)*, where the outlines of the table-top are indicated by incisions rather than the contrast between light and dark.

Furthermore the backgrounds to many of his still lifes had become little more than abstract shapes rather than depictions of objects, as in *1933 (musical instruments)*, although it is possible here to read the form of a table. Nicholson was beginning to regard a painting not so much as a depiction as an object in itself. The stress on the physical nature of painting, on the substance of paint and support had been increasing throughout the previous decade to the point where he was painting on pieces of board whose identity as board was emphatically asserted, for example in *1932 (prince and princess)*, *1932 (guitar)* and *c. 1932 (still life and guitar)*. In the latter Nicholson gouged out a chunk of gesso penetrating right back to the board itself, thereby

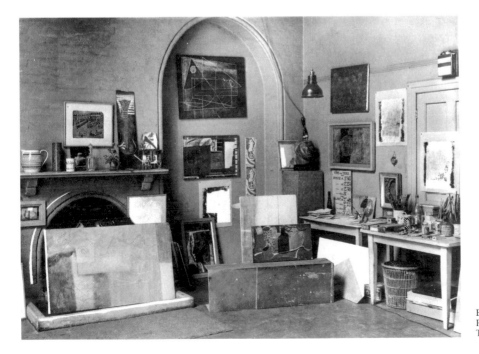

Ben Nicholson's Studio. 1933.
Photo Barbara Hepworth.
Tate Gallery Archive

14

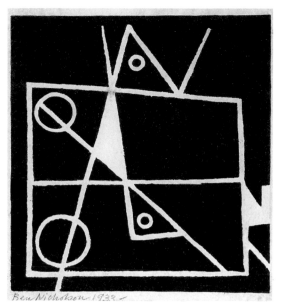

1933 (Foxy and Frankie 5). Linocut, 6 ³⁄₁₆ × 5 ¾ in. (15.7 × 14.6 cm.). Private collection.

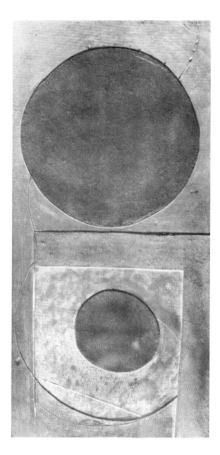

December 1933 (first completed relief). Oil on carved board, 21 ½ × 10 in. (54.5 × 25.5 cm). Private collection.

asserting both the surface and the support and exploiting physical depth. The ambiguous status of *1932 (guitar)* — painting or object or both — is indicated in a photograph of Nicholson's studio, taken in 1933 by Barbara Hepworth, where it stands unframed, propped against the wall on the mantlepiece. Its object-quality is emphasised by the retention of its ragged top edge. Beside it hangs a painting by Alfred Wallis in whose work Nicholson identified a similar ambiguity. The stress on the object quality of his work was compounded by his activity at this time in painting actual boxes some of which were very small. Indeed throughout his life Nicholson created many very small works some of which, although intimate, have a grandness of scale, for example *1934 (relief)* or *c. 1933 (bus ticket)*.

Nicholson may have been encouraged to explore the possibility of carving into board not only by his experience of incising it but also by his interest in linocuts, which he had been making since 1926. His activity in this field had increased in 1933 and the act of carving into lino may have suggested such a possibility with wood. In addition, with Hepworth sharing his studio, the temptation to take up the chisel must have been considerable.

According to Nicholson the literal breakthrough into relief occurred by accident. Working on a painting, he was following his usual practice of incising the surface but at the intersection of two lines he noticed that a chip fell out. He began to exploit the accident and found himself working in relief. Since he had almost abandoned the depiction of depth it was ironic that he should create actual depth. The first completed relief — there may have been others which were destroyed or not completed — has the object quality of *1933 (guitar)* but is non-figurative. Two ovals are carved out of board and set within two roughly hewn rectangles. The ovals derive from Nicholson's interest in Miró and

Calder, and possibly from the earlier depiction of guitars with circular openings, and were probably directly preceded by paintings such as *1933 (red and lilac circle)* and *1933(painting)* in which Nicholson links brightly coloured discs by armatures. In a letter to John Summerson Nicholson stated that

> I think the first abstract painting which registered with me was a Miró, about 1925–27 which I saw at Pierre Loeb's gallery in Paris in 1932 — it was the first free painting that I saw and it made a deep impression... One can only accept what one is ready for and this I was ready for. (13 May 1944)

In *1933 (first completed relief)* the discs are painted in subdued colours allowing the perception of depth to be gauged through the form rather than through the colour. The first relief was made in Paris in December 1933 during a visit to see Winifred and the children and was followed by a number of small reliefs in greys and browns and occasionally a sombre red as in *1933 (painted relief)*. *1933 (six circles)*, an exceptionally large relief of this period, is also one of the shallowest and in some respects harks back to earlier concerns. For example the areas of the paint do not coincide with the edges of the carved or incised circles, as was noted in *1924 (goblet and two pears)*, and the manner in which he has painted a grid of lines is not too dissimilar from the depiction of the table-top in *1933 (composition in black and white)* and *1933 (milk and plain chocolate)*.

The painted relief was obviously an exciting idea for Nicholson and on his journey home from Paris by

aeroplane from Le Bourget airport, he perceived the flight of the plane through the clouds in the manner of one of his works. Writing to Winifred Nicholson on 30 December he described the trip in detail:

> I saw some nice French fields all laid out in small squares and then went above some white clouds which stretched out on one plane to the horizon — and the sun shining high up and blue sky indefinitely.
> I felt as though the whole thing (aeroplane) was sustained by thought — and very powerfully sustained — it flew quite evenly an exact distance above the white clouds for 2 hours — with what seemed like a tremendous noise...
> As the time of arriving drew near I expected to go down at a slight incline through the clouds gradually arriving at the aerodrome and then descend — but not a bit — suddenly the engines almost stopped and we went down at a steep angle into the white bank of cloud — for a few minutes one saw nothing not even a few feet ahead — and descending very steeply and banking at what seemed a very steep angle we descended in a half turn in almost a second on to Croydon in a grey winter's evening and London suburbs (quoted in Andrew Nicholson [ed.], *Unknown Colour*, London 1987, p. 142)

In the same letter Nicholson clearly associates his new ideas with the sort of experience he had in the aeroplane and refers to Winifred as working on the 'same translucent aeroplane ideas'. The ability to pass from one level to another with abruptness and precision, bypassing intermediate planes, is a quality found in Nicholson's reliefs and was paralleled in his description of the flight. The purity of the white cloud, moreover, may have had some bearing on his next major advance, the making of white reliefs.

The first white reliefs were executed in 1934 and were exhibited at the exhibition of the Seven and Five Society at the Leicester Galleries in March. The reduction of colour to white may have resulted from a desire to concentrate on pure form at the expense of colour but other influences may have come to bear on Nicholson. It is clear from Winifred's letter to Ben that they had been engaged in deep and articulate discussion about the nature of their current painting during the latter's visit to Paris at the end of 1933 and, in particular, on the nature of light in painting, a subject which Winifred found particularly fascinating. In her response to the letter quoted above she states:

> The impressionists used light to discover colours — the Cubists assembled planes of light taken from the appearance of the objects. They used light as a building material, but they could not liberate it completely from the influence of the objects they extracted it from. It is for us to liberate light... *A nous la libération de la lumière* — That and some other things even more important (ibid., p. 144).

The white reliefs are a manifestation of the liberation of light from the depicted object, although not from the object itself, since above all else the reliefs are physical things.

White had been important during the Castagnola years in the form of snow and, furthermore, during his visits to St Ives, Nicholson must have enjoyed the sight of the white fishermen's cottages glistening in the bright light. But white was also a modernist colour, employed particularly in the new architecture in which Nicholson was very interested, examples of which were to be seen in Hampstead and Highgate and in Paris. In a period of slum clearance, when greater emphasis was placed on health and cleanliness in the building of health centres and the encouragement of outdoor exercise, the creation of the white reliefs, described by some critics as sterile and 'disinfected', were representative of their times. White symbolised a new beginning in life and art, as Paul Nash noted in his review of Nicholson's exhibition at the Lefevre Gallery in 1935: 'The white reliefs should be regarded as something like the discovery of a new world.' ('Ben Nicholson's Carved Reliefs', *Architectural Review*, October 1935).

The purity of these works endows them with an almost metaphysical quality at which Nicholson appears consciously to have aimed. In his statement in *Unit One* he wrote:

> As I see it, painting and religious experience are the same thing, and what we are all searching for is the understanding and realisation of infinity — an ideal which is complete, with no beginning, no end and therefore giving to all things for all time.

The equation of painting with religion and mysticism was fairly commonplace in this period, artists such as Mondrian and Kandinsky, both of whom were known to Nicholson, being foremost among those who encouraged the connection. At this time Nicholson was a believer in Christian Science (Winifred adhered to the faith throughout her life), a fundamental tenet of which is a belief in a deeper reality beyond or beneath the materiality of world appearance. The white reliefs may embody similar ideas, a search for universality.

The concept of the white reliefs may owe something to the work of Malevich although Nicholson claimed not to have seen a painting by Malevich at this time. Malevich's Suprematist paintings, however, bear little physical relationship to Nicholson's reliefs. The reliefs have more of an affinity with Mondrian's black and white paintings of 1930 in their purity and starkness — his visit to Mondrian's studio in 1934 left a deep impression on him — although the boldness of Mondrian's black grids prevents the dissolving of form encountered in a white relief. In spirit the latter seem close to the theories of Kandinsky who, in *Concerning the Spiritual in Art*, published in English in 1914, envisaged the possibility of an all white painting:

> White is the symbol of a world from which all colour as a definite attribute has disappeared. The world is too far above us for its harmony to touch our souls. A great silence, like an impenetrable wall, shrouds its life from our understanding. White, therefore, has this harmony of silence, which works upon us negatively, like many pauses in music that break temporarily the melody. It is not a dead silence but pregnant with possibilities. White has the appeal of nothingness that is before birth, of the world in an ice age.

The white reliefs, intended to hang on the white walls of modernist houses, have a sense of infinite depth but not expanse since they are bounded by grey frames. They were perceived by the critics as objects of pure form divorced from life, an expression of art for art's sake with no mimetic or associative functions of any serious import. As such they might represent the culmination of all that Clive Bell had expressed in *Art* in 1914: 'To appreciate a work of art' he wrote, 'we need bring with us nothing from life... For a moment we are shut off from human interests... we are lifted above the stream of life.' However, even though the white reliefs represented the purging of colour from painting, whiteness, as has been stated, did have significant connotations.

For Nicholson the white reliefs were an expression of a 'constructive idea'. The constructive movement, in which he was a leading participant, sought to establish unity in painting, sculpture, architecture and life, observing in all areas of life and nature a series of common forms. It called for a collaboration between artists, architects and intellectuals to create a utopian world of harmony. There was optimism in the future of a world where abstraction would be a universal language, where buildings would be constructed along clean, crisp lines and where function would be closely allied to form and needs. Architecture, like Nicholson's reliefs, was modular and reductive and made considerable use of natural light to animate and enlarge space. Exhibitions such as 'Modern Pictures for Modern Rooms', held at the Duncan Miller showrooms in 1936, were mounted in order to demonstrate to the public that modern art could be accommodated within the domestic interior and that it was consonant with contemporary design.

Further crossing of boundaries had occurred in 1933 when Nicholson and Hepworth had carved a number of lino blocks and printed them as fabrics and in 1934 when Nicholson produced designs for Léonide Massine for his new symphonic ballet to Beethoven's Seventh Symphony. *1934 (Florentine ballet)* is closely related to *1934 (first scheme for Massine ballet)* (Kettle's Yard, University of Cambridge) which is one of two schemes known to exist, the other being a white relief (private collection). Nicholson's designs were not used, however, and when the ballet was finally performed in Monte Carlo in May 1938 it was before the severely classicising sets by Christian Bérard. Nicholson also created fabric designs for Edinburgh Weavers and was one of a number of British artists in the thirties who designed posters for corporate advertising (for example Shell and Imperial Airways).

The zenith of the movement which promoted the unified aspect of life was the publication in 1937 of *Circle–International Survey of Constructive Art* edited by Naum Gabo, J. L. (Leslie) Martin (the architect) and Ben Nicholson. It was intended to be a magazine but, because of the outbreak of war, never proceeded beyond the first issue.

1935 (white relief). Oil on carved board, 21 ½ × 31 ½ in. (54.5 × 80 cm). The British Council.

The first white reliefs were carved freehand in the manner of the early painted reliefs but Nicholson soon began to regularise his compositions by using ruler and compass to plot the rectangles and circles, although sometimes, as in *1935 (white relief)*, he combined both methods of execution. The balance of a composition was of paramount importance, Nicholson intuitively juxtaposing rectangles and circles as Mondrian would areas of colour within his gridded compositions. As the decade progressed the compositions became more complex and illusionism began to play a role again, as in *1939 (white relief)* where the circle is drawn not carved. The size of the reliefs also increased. Proportion played an important role in the realisation of these works and frequently the principal elements were located in either a calculated or intuitive way on the Golden Section, again possibly suggesting some kind of metaphysical import. The Golden Section was also frequently upheld as the basis for both classical Greek and modernist architecture and was advocated as an important proportional device by Le Corbusier in his many articles, some of which were published in *l'Esprit nouveau*. Nicholson's reliefs, therefore, were as allied to architecture and design as they were to painting and sculpture, an alliance which he and his contemporaries recognised and which was manifested in *Circle*. Not to underplay the sculptural nature of his work, it should be noted that he executed two white relief sculptures in the mid thirties.

In 1941 Nicholson described a typical relief and the importance of intuition in its making and in its viewing:

> You can take a rectangular surface and cut a section of it one plane lower and then in the higher plane cut a circle deeper than, but without touching, the lower plane. One is immediately conscious that this circle has pierced the lower plane without having touched it... and this creates space. The awareness of this is felt subconsciously and it is useless to approach it intellectually as this, so far from helping, only acts as a barrier. ('Notes on Abstract Art', *Horizon*, October 1941.)

It was Nicholson's practice to work with the radio on, which helped him to be distanced from his surroundings and to work intuitively.

The white reliefs were Nicholson's principal contribution to the modern movement but he did not neglect his painting in this period. Although he had purged the Seven and Five Society of all figurative artists by 1935, insisting that only abstract artists could show in that year (which was to see the demise of the society), he himself continued to paint still lifes or still-life based compositions incorporating bright colours. In the mid thirties Nicholson often reworked earlier canvases, scraping them back and painting on top of an already formed ground, creating an impressionistic mist out of which forms could emerge. In *1933–5 (still life with bottle and mugs)* and *1931–6 (still life - Greek landscape)* he combines his experience of painting still life with the newly acquired lessons derived from making reliefs. While the mug on the right of the former is painted in actual shallow relief, the surface of *1931–6 (still life - Greek landscape)* is smooth, although Nicholson creates the illusion of relief by incorporating heavy shadows, as indeed he did as early as 1932 in *1932 (prince and princess)*, which has the appearance of being a board on a board.

In *1931–6 (still life - Greek landscape)* the illusion is given of a variety of spatial planes and the overlapping of objects is more pronounced than in earlier still lifes. While the concentration of forms in a small space is more closely related to the model of earlier Cubist paintings than were the compositions of his own earlier paintings, the immaterial nature of the objects depicted is particular to Nicholson. The shadows somehow seem more substantial than the objects themselves which are transparent and evanescent. Nicholson had developed a confident, lyrical facility for the linear depiction of objects which combined elegance, wit, poise and rhythm rarely found in the work of other artists. *1934 (still life: birdie)* shows this lyrical, linear quality with its flowing, serpentine line rendering the goblet malleable and almost anthropomorphic, the coloured discs, derived from Nicholson's abstract paintings of the previous year, suggestive of eyes.

The still lifes and abstract paintings of the thirties saw a further exploration of colour. Whereas before the creation of the white reliefs Nicholson had generally employed dark earthy colours, the experience of making the white reliefs appears to have encouraged him to change key and adopt a brighter palette. It has been suggested that he was influenced in this by his knowledge of Mondrian's pantings, which he had seen when he visited his studio in the rue du Départ, Paris in 1934 and 1936, but Nicholson had begun to change to brighter colours earlier than that. While undoubtedly Mondrian made a great impact on Nicholson, particularly in regard to the poise and balance of his paintings and the use of flat areas of colour, Nicholson's works of the late thirties should be seen as much as a natural development out of his own work rather than as the assimilation of Mondrian's influence. While there are resemblances between *1937 (painting)* and Mondrian's art they remain superficial. Nicholson's

painting is more complex in composition and colour and retains links with the earlier still lifes and the very early paintings of 1924 such as *1924 (trout)*. The colours are both primary and tonal mixtures and, while divided into strictly geometric shapes, they are not controlled by a grid. Such paintings seem to declare an interest in the space creating characteristics of colour in contrast to the theosophical intentions behind Mondrian's.

Although Nicholson continued to make white reliefs throughout the thirties he must have recognised the limitations in working in this vein because colourful paintings and reliefs came to predominate in the closing years. Colour was seen by constructive architects, such as Leslie Martin, as being of architectural importance.

> One of the most important aspects of painting in this category is its constructive use of colour; in Nicholson's work this is illustrated by several developments. First by his adoption of primary colours. Probably for the sake of complete clarity, red, yellow and blue, together with white and black, were added to the neutral background that had been used in earlier work. These basic colours avoided ambiguity; they worked with a maximum intensity; they displayed in the clearest way colour properties, effects of projections and recession. These colours became forces and thrusts posed against each other, and maintaining equilibrium only by their exact balance. Once these stages had been worked out, the colour range was gradually enlarged until, in the latest paintings, many varieties of colour have been included, but always with this condition, that each colour performs a special function in relation to the other colours of the painting — it becomes a constructive element. (*Focus*, no. 3, 1939.)

Nicholson used colours in a variety of combinations which were never pure like Mondrian's but always complex and sometimes surprising. His paintings ranged from the intense to the ethereal, sometimes combining colours from both polarities. Just as the white reliefs became compositionally more complex so did the coloured abstract paintings. Like the white reliefs, however, the geometric paintings of the late thirties eschewed surface incident and maintained a smooth impasto. This was the only time in Nicholson's career when he did not favour a highly textured, weathered surface, presumably in order to depersonalise and purify the work so that colour and form became the subject.

By the time war broke out London had become the European centre for constructive art. Refugees from the continent had arrived throughout the decade, including Naum Gabo, Moholy-Nagy, Marcel Breuer, Walter Gropius and Piet Mondrian, many of them settling in Hampstead or its environs. Many of these artists and architects came to London as the last European haven from Fascism and because of the climate of modernism which Nicholson had created, not only through his own work but through his activity as president of the Seven and Five Society and his active participation in other groups. By the mid thirties he was a painter of international repute, exhibiting

in Alfred Barr's 'Cubism and Abstract Art' in New York in 1936, 'Thèse, antithèse, synthèse' in Lucerne in 1935 and 'Abstrakte kunst' at the Stedelijk Museum, Amsterdam in 1938. He had been elected a member of 'Abstraction-Création' in 1933 along with Barbara Hepworth (the only other British member was Edward Wadsworth) and had exhibited with the group in 1934. His work was featured regularly in magazines such as *Axis* edited by Myfanwy Evans, the wife of John Piper, and was also to be found in *Cahiers d'Art*. He had contributed a woodcut to *23 Gravures*, a book of prints edited by Anatole Jakovski in Paris which included works by Picasso, Ernst, Giacometti, Kandinsky, Léger, Arp and others and through his contacts with artists had helped Nicolete Gray to organise the 'Abstract and Concrete' exhibition which toured England in 1936 and which included a number of the important continental abstract artists such as Hélion, Mondrian and Kandinsky. Along with Calder, Miró, Duchamp, Kandinsky, Picabia, the Delaunays, Arp and Moholy-Nagy among others, he was also a signatory to the Dimensionist manifesto edited by Charles Sirato and published in Paris in 1935. His allegiance to such a mixed cause suggests that Nicholson was still not averse to being associated with certain elements of Surrealism. He was a force not only in English art but also in Europe.

The forties

Shortly before the declaration of war on 3 September 1939 Adrian Stokes, the painter, writer and theorist invited the Nicholsons to move to Cornwall with their children (the triplets were born in 1934) and to share the Stokes's house in Carbis Bay. Life with the Stokes family was cramped. Nicholson worked in Stokes's studio, Stokes worked in another big room and Hepworth in the bedroom when she had time off from looking after the chidren. Nicholson continued to work hard and when not at work was looking for other artists with whom he could form a fruitful relationship. His experience in the thirties of the atmosphere of international co-operation as well as of the Seven and Five Society led him to place faith in groups and he enjoyed manoeuvering people and arranging events. Naum Gabo had followed the Nicholsons to Cornwall and they tried to persuade Mondrian to do the same but he had a dislike for countryside and emigrated to New York in 1940. To some extent the avant-garde had transferred to Cornwall but facilities were poor for work and times were hard. The Nicholsons moved to their own accommodation in December 1939. Nicholson continued to make reliefs and abstract paintings but these were principally small projects for intended larger works which were often not made for lack of studio space and materials. In order to earn a living he returned to painting landscapes in a naïve style which his gallery, Alex Reid and Lefevre, considered easier to sell. The return to landscape was generally

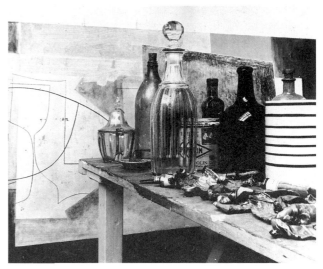
Ben Nicholson's studio, St. Ives. Photo Bill Brandt.

to be observed in English painting during the war as Britain reverted to a period of isolation.

The cramped conditions at their house 'Dunluce' resulted in a considerable drop in output and in September 1942 the Nicholsons moved to a house called Chy-an-Kerris on the far side of Carbis Bay which gave Nicholson more, albeit not much more, space. Paintings of this period were small and rehearse and develop the ideas which he had worked out in the thirties. A number of them are more complex, such as *1944 (three mugs)* in which he depicts an intricate interweaving of mug handles and decorative pattern within a Cubist structure. The bright palette is a development from the abstract paintings of the late thirties. Other paintings develop the theme of the still life set before a window which Nicholson, along with many other members of the Seven and Five Society, including Winifred Nicholson, had enjoyed during the late twenties. *1944 (still life and Cornish landscape)* depicts the familiar domestic motifs on a table before a window beyond which is a view of St Ives and St Ives Bay. In such compositions Nicholson was interested in being able to unite objects in the foreground with those in the background, allowing the eye to travel over large distances and periods of time in one glance. In this case the jug and the house are depicted almost in the same plane and owing to their relative similarity of scale the house is brought into the composition as another still life motif. Unlike many of the other paintings of this period, this work is painted in subdued tones alleviated by a few highlights of red and yellow. Others, such as *1943–5 (St Ives, Cornwall)* (Tate Gallery) are keyed in brighter colours, notwithstanding the Union Jack painted in celebration of VE day, a characteristically witty addition.

The impact of the landscape on Nicholson's work was considerable. After his move to Cornwall he ceased to make white reliefs, which could be interpreted as an urban art, and reintroduced subdued colours as well as brighter tones which appear to be derived from

his surroundings. *1944 (still life and Cornish landscape)* is redolent of autumn while *1941 (painted relief)* is suggestive of the bright light and glare of the Cornish peninsula. Even before he had left London Nicholson was returning to a more sombre palette, as in *1939 (painted relief)*, but the renewed experience of painting landscape encouraged him to reintegrate earth colours with bright, sharper primaries.

In addition to landscapes and small relief projects, Nicholson made small works combining painting with vigorous drawing such as *1945 (parrot's eye)*, which builds on the structure of a relief such as *1933 (six circles)* but depicts a complex series of armatures which act as both a containing grid and as a highly animated design. Drawing became one of Nicholson's principal activities during the war, since it required less space and time, but he used the pencil in a way analagous to the chisel, scoring into the paint to create different depths or using it to create the illusion of depth through shadow. Alongside these abstract paintings and drawings, he produced many sketches from the motif, frequently of rooftops in St Ives with their complex, naturally cubistic configurations, or of tin mines which stand in the rugged Cornish landscape like ancient relics.

The end of the war heralded the beginning of a new era in Britain and signalled a new beginning for Nicholson. Instead of returning to London, Nicholson and Hepworth chose to remain in Cornwall and became actively engaged in the local art scene, encouraging younger artists such as Peter Lanyon (who had been a pupil of Nicholson and Gabo) and Terry Frost and helping to found the Penwith Society of Arts in Cornwall in February 1949, of which Herbert Read was elected President. In 1947 Lund Humphries published the first substantial monograph on Nicholson with an introduction by Read. The second volume was to follow in 1956.

In the immediate post war years Nicholson embarked upon a series of abstracted, cubistic still lifes which were to be the foundation for the major paintings of the fifties. These paintings, such as *1947 (still life - spotted curtain)*, are characterised by flattened forms, contrasts of sharp and sombre tonalities, cursive rhythmic line and considerable weathering of texture. Whereas in the late thirties the still lifes emphasised the interpenetration of motif and ground, the use of opaque colours in the post war works respects the integrity of the depicted object. The colours employed contrast with the ground rather than merge with it. This practice appears to have developed out of the renewed concentration on still life objects during the war and his continued interest in abstraction. Furthermore, the objects were now grouped together in dense clusters whereas in the early thirties he had portrayed them more evenly distributed across the canvas. As a result Nicholson was able to assert the object quality of the mug and flasks by grouping while at the same time emphasising the flatness of the surface. This is evident in works such as *1947 (Mousehole)*, *July 22–47 (still*

life–odyssey 1) and *1949 (poisonous yellow)*. Although he continued to make reliefs in this period they were less numerous for the simple reason that still life objects '[gave] a wider variety on which to play' than circles and rectangles (letter to Herbert Read 1953).

The greatest impact on Nicholson's work, however, came from the move to a large studio backing onto Porthmeor Beach, St Ives in 1949. In a letter of application for the studio, which was part of a studio complex administered by the Borlase Smart Memorial Trust, Nicholson wrote that he was working in a small converted bedroom and that 'this imposes a very definite limit on the size of paintings I can make' (letter to Philip James, 24 May 1949). The move to the large studio, which had only top lighting and no view, permitted Nicholson to work on a larger scale and to produce what were arguably his finest, most ambitious paintings, the grand baroque still lifes of the fifties.

The fifties

One of the characteristics which distinguishes these paintings from previous still lifes, apart from their increased scale and size, is the rich and deep colour. Thus *December 1953 (Night Facade)*, *1959 (Argolis)* and *August 1956 (Val d'Orcia)* are highly atmospheric, the ground acting as more than a support for the motif by actually providing a setting in much the same way as a landscape, except that here the two are synthesised in a way only hinted at in previous works. In some of these still lifes, notably the latter two and the earlier *April 1950 (Abélard and Héloise)*, Nicholson returned to a lateral spread of objects which somewhat dissipates the object quality of the motifs while at the same time setting up greater rhythmic variety and visual rhymes. He returned once again to a more linear depiction of the object, no more so than in 1951–3, at times expunging colour almost completely as in *December 1951 (opal, magenta and black)* and *July 1953 (Cyclades)* where linear designs are laid over delicate washes of

May 22-50 (cloisters, San Gimignano). 1950. Pencil on paper, 15 × 20 in. (38.1 × 50.8 cm.). Arts Council of Great Britain.

colour. The latter is one of a number of curved panel paintings Nicholson executed in this period which he was encouraged to do after completing a commission to decorate two concave panels for the steamship *Rangitane* belonging to the New Zealand Shipping Company. The effect of the curve is to reinforce the tension of the drawing which, unusually for Nicholson, runs almost from edge to edge in a highly spacious manner. The objects are portrayed on a greater scale than in other still lifes, but perhaps with less complexity, and the curve serves to concentrate the form.

The linear nature of the still lifes of the fifties is a distinguishing characteristic. There is a tension in the razor sharp lines and this keenness must have developed out of Nicholson's experience of minutely differing depths of plane in the relief, as well as from his increased drawing activity during the war. Indeed drawing had become an important part of his working method as a means of investigating form. Being essentially abstract, line may be imposed upon or integrated with areas of broadly painted colour so that background and motif can exist in the same plane. There is a certain magic in the way that Nicholson suddenly inserts space by juxtaposing the finest, precise lines with broadly brushed colour as in *December 1955 (night façade)* or *August 1956 (Val d'Orcia)*. Where he depicts a complex linear configuration he usually confines his colours to well defined areas and uses few of them. On the other hand, when the complexity of the configuration is found in the juxtaposition of colours he generally employs few lines. Examples of these combinations may be found in *August 1956 (Val d'Orcia)* and *February 1953 (contrapuntal)*. There are however exceptions to this where both the linear configuration and the colour composition are complex as in *June 4–52 (tableform)* and *November 1957 (yellow Trevose)*. During this period Nicholson experimented considerably with the format of his compositions, sometimes extending them laterally across the canvas or board, at other times stacking the forms like an architectural edifice or a totem pole.

The relationship between still life and architecture was remarked upon by Nicholson, who enjoyed drawing buildings and ruins on his travels. Trips to Italy and other Mediterranean countries and islands were remembered in the titles of many works from the fifties onwards as were the conditions of light, weather and colours he perceived. It would be plausible then to see in these grand paintings a translation of his perception of the relationship between buildings and the landscape. The still life became an analogy for rather than a depiction of what he saw. He made no distinction between representational and non-representational painting, claiming that the painting he liked was both musical and architectural expressing a relationship between form, tone and colour regardless of its classification as abstract or representational.

While Nicholson returned to a more linear depiction of the motif in the still lifes of the fifties he continued to texture the surface suggesting tactile materiality to counterbalance the immateriality of the linear object. This is evident in a painting such as *Feb. 28–53 (vertical seconds)* and was to be of importance in the later reliefs of the sixties.

Nicholson's career, like that of Moore and Hepworth, had flourished in the fifties. All three artists were promoted in a series of exhibitions mounted by the British Council in Venice and São Paulo among other places, and all began to exhibit regularly in North America, especially in New York. Nicholson's achievement was recognised by a series of awards by international juries — first prize for painting at the Carnegie's 39th International Exhibition 1952, the Ulisse Award at the XXVII Biennale, Venice 1954, the Grand Prix at the fourth Mostra Internazionale di Bianco e Nero, Lugano 1956, First Guggenheim International painting prize 1956, first prize for painting at the IV São Paulo Bienal 1957 and later the Rembrandt Prize 1974 — and his sales, which had been poor during the previous twenty years, increased dramatically. The triumvirate of Moore, Hepworth and Nicholson established British art as a force with which to be reckoned and in Britain they created a climate which encouraged younger artists to develop. The example of Nicholson and Hepworth was of considerable importance to the burgeoning group of artists who assembled in St Ives in the fifties, while Nicholson's approach to art also provided a point of debate among Constructivist artists such as Kenneth Martin and Victor Pasmore and abstract artists such as Peter Lanyon and Patrick Heron.

By the end of the fifties Nicholson began to simplify his compositions. The complex configurations of *December 1951 (St Ives - oval and steeple)* or *Nov. 51 (still life–seven)* with their webs of interlaced lines were replaced by more sedate configurations in which poise and balance were more important than energetic rhythms. His move to Switzerland in 1958 following his marriage to Felicitas Vogler in the previous year (he had separated from Hepworth in 1951) may have occasioned another change in his work. Vogler, a photographer, and Nicholson shared an interest in detail and textures, in ancient buildings and monuments

Aug. 13-54 (St. Agnes). 1954. Pencil on paper, 15 × 22 in. (38 × 56 cm.). Ivor Braka Limited, London.

and in the encounter of classical forms in everyday surroundings. They built a house high up above Lake Maggiore in the Ticino where Nicholson was impressed by the scale and magnificence of the mountain landscape. Although he continued to make still lifes, relief carving once again became his principal occupation.

The reliefs were made on a scale never previously achieved and were frequently monumental, culminating in the relief wall he made at Documenta III in Kassel (subsequently destroyed). This, like the only existing wall at Sutton Place, was set beside a pool of water. Indeed a number of the smaller late reliefs were intended as projects for walls which Nicholson envisaged building but which were never achieved.

September 1961 (road near Olympia). Pencil and wash on paper, 18⅛ × 23¾ in. (46 × 60.3 cm). Private collection.

The sixties

Just as the fifties had seen the culmination of the still life so in the sixties and the seventies Nicholson's carving reached its zenith. The colours of the reliefs were undoubtedly related to the landscape and were generally tonally subdued although punctuated by sharp colours. While *1966 (Zennor Quoit)* makes reference to the broad Neolithic passage grave in Cornwall of that name, its abnormal width may also suggest the expansive views obtained from the terrace of Nicholson's house. Similarly *1967 (Tuscan relief)* is redolent of the Tuscan landscape with its earth browns and faded greens. It is no coincidence that Nicholson enjoyed visiting Neolithic sites such as Carnac in Brittany, naming one of his finest late reliefs *1966 (Carnac red and brown)* after this ancient site. The textures are weathered and scraped like stones and the colour is worked into the surface so that the two become inseparable. As Nicholson stated in 1955:

> In a painting it should be impossible to separate form from colour or colour from form as it is to separate wood from wood-colour or stone-colour from stone. Colour exists not as applied paint but as the inner core of an idea and this idea cannot be touched physically any more than one can touch the blue of a summer sky. (Notes in Tate Gallery exhibition catalogue 1955.)

Nicholson's description of the view from his house written in 1959 could easily pass for a description of a relief:

> The landscape is superb, especially in winter and when seen from the changing levels of the mountainside. The persistent sunlight, the bare trees seen against a translucent lake, the hard, rounded forms of the snow topped mountains, and perhaps with a late evening moon rising beyond in a pale, cerulean sky is entirely magical with the kind of poetry which I would like to find in my painting. (Quoted in M. de Sausmarez [ed.], *Ben Nicholson*, London 1969.)

Many of the characteristics of the landscape which he describes here are found in his work; translucence, cerulean blues, vertical lines seen against areas of flat

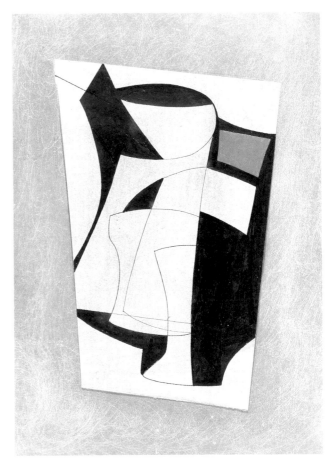

1965 (still life). Oil and pencil on paper mounted on board, 18¾ × 13¾ in. (47.5 × 35 cm). Private collection.

tened colour, rounded forms with rectilinear forms. Above all, however, Nicholson softened the shapes in his composition introducing curves where previously he had hard straight edges, and texturing the ground in such a way that the surface became delicately scratched or pitted rather than harshly weathered. Many of these works evoke with extraordinary subtlety the forms and textures of ancient stones, buildings and monuments which Nicholson saw on his travels. The curved forms, like the curved surface of some of the

paintings of the early fifties, tensions the relief like a coiled spring. In *1967 (Tuscan relief)* or *1969 (monolith Carnac 5)* the composition is given a dynamic different from the stasis of the earlier reliefs. In contrast to the early reliefs where movement, which was recessive, was created by carving or by colour juxtapositions, in the late reliefs movement is often lateral and recessive as forms collide or lock into each other, the planes being curved or set at angles rather than parallel to the frame.

Although it would be wrong to read these reliefs as evocations of specific places named in the titles, they undoubtedly have a landscape feel and an impressionistic air. The misty surface and close range of tones of a relief such as *1966 (Erymanthos)* do not seem all that far distant in feeling from *1925 (Bankshead studio looking east)*, the circles in the former being as differentiated from their ground as the fencing in the latter.

The size of the late reliefs required a change in working methods. Some of the reliefs were so large that they could no longer be carved on a table top but probably required Nicholson to crawl over them, calling for a greater physical involvement than was previously necessary. The production of the relief required the application of the whole body, not just the hands, but they remained objects of great delicacy. The subtle changes of level in *1966 (Erymanthos)*, the finely incised circle, the balance of forms and the subtle modulation of tones testify to Nicholson's continuing sensitivity and acuity of vision.

As the reliefs became larger so the handling of form, colour and line tended to become broader. In addition to the curved edges Nicholson loosened up his brushwork, applying the paint freely, as in *1971 (Dolphin)* or *1971 (Obidos Portugal 3)* where the expansive white gestures extend beyond the carved edges of motifs. Even in earlier works, such as *1966 (Zennor Quoit 2)*, the handling of the white is more freely and expansively brushed than in previous years. The forms themselves became less complex and from a succession of reliefs with tight interlocking planes Nicholson moved to simpler and more monumental compositions.

The final years

In 1971 Nicholson returned to England and moved to Cambridge to live with Leslie and Sadie Martin, friends from his days in London in the thirties. He moved back to Hampstead in 1974. The last seven years of his life were spent largely making works on paper, his failing health and eyesight preventing him from working on a large scale. The late gouaches saw a continuation of the architectural drawings and a return to the still life theme showing a mastery of line and a continuation of the witty characterisation of the object so prevalent in earlier still lifes, particularly in the twenties. In addition to the standard vocabulary of jugs, mugs, goblets and carafes Nicholson drew tools, bringing the sheet to life not only by his quick-witted characterisations but also by the most delicate of washes, a veil through and against which the object could be perceived and which gives body to objects otherwise portrayed in outline only. While Nicholson's line had been playful in the grand still lifes of the fifties the final appearance of the paintings was weighty. The late drawings appear altogether more spontaneous, the product of pure enjoyment and highly expressive of the pleasures of drawing. The variety of linear expression which Nicholson achieved was considerable; nervy wiggles, assured sweeps, tangled scribbles, careful descriptions and rapid characterisations. Line has the ability to suggest flatness and great depth of space and Nicholson exploits its dual nature at times to startling effect. Each sheet represents the complex balance between sharp line, delicate wash and dense shading, an art which Nicholson possessed to the end of his life. Although failing health did not permit him to work on a grand scale in the last ten years of his life the late drawings demonstrate a continuing vitality of thought and vision.

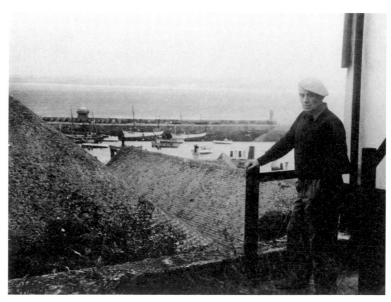

Ben Nicholson in St. Ives, *c.* 1955. Photo Charles Gimpel. Tate Gallery Archive.

Biography

1894. Born 10 April Denham, Buckinghamshire. Eldest son of William and Mabel (née Pryde) Nicholson. Family lives in Woodstock 1897–1903.

1897. Birth of Tony Nicholson (brother died 1918).

1899. Birth of Nancy Nicholson (sister, textile designer, died 1977).

1903–10. Educated at Heddon Court, Hampstead and for one term at Gresham's School, Holt. Family live in London.

1904. Birth of Kit Nicholson (brother, architect, died 1948).

1910–11. Studies at Slade School of Fine Art for three and a half terms. Befriends Paul Nash.

1911–12. Spends four months in Tours learning French.

1912–13. Studies Italian in Milan.

1913–14. Visits Madeira for reasons of health.

1914. Returns to England on outbreak of war. Exempted from military service owing to ill health.

1917–18. Brief stay in Pasadena. Returns to England on receiving news of mother's death. Brother Tony dies on active service.

1920. Marries Winifred Roberts, herself an artist. They live at Bankshead near Brampton, Cumberland and in Chelsea. 1920–24 they spend winters in Lugano, Switzerland and make visits to Paris. On one of these visits in 1921 Nicholson sees a 1915 Picasso at Paul Rosenberg' gallery which has a strong impact on him.

1922. First one man exhibition held at the Adelphi Gallery, London.

1923. Stays with Paul Nash in Dymchurch, Sussex where they paint together. Shares an exhibition with Winifred Nicholson at Patterson's Gallery, London.

1924. Elected a member of the Seven and Five Society. Nominated by Ivon Hitchens. In April shows *Andrew* at the London Group exhibition as a non-member. Paints a number of abstract paintings only three of which are known to have survived. Has a one-man show at the Adelphi Gallery, London and exhibits in the Seven and Five Society exhibition.

1926. Becomes President of the Seven and Five Society, a post he holds until its demise after 1935. Meets Christopher Wood in July. Exhibits in the Seven and Five Society exhibition. Around this time begins to make linocuts.

1927. Beginning of primitive landscape style, a development of his 'naïve' approach to still life. Exhibits in the Seven and Five Society exhibition and in April shares an exhibition at the Beaux Arts Gallery, London with Christopher Wood and the potter and painter William Staite Murray. Birth of first son, Jake.

c. 1928 (breakfast table, Bankshead-Villa Capriccio). Pencil on paper, 13½ × 16⅞ in. (34.3 × 42.8 cm). Trustees of the British Museum.

1928. In March Wood is a visitor to Bankshead where he paints in the company of Ben and Winifred Nicholson often outdoors. In the Summer they spend two and a half months together in Cornwall. In August, on Wood's and Ben Nicholson's first trip to St Ives, they discover Alfred Wallis, the fisherman painter. Exhibits with the Seven and Five Society and in July shares an exhibition at the Lefevre Gallery with Winifred Nicholson and William Staite Murray. Makes a number of linocut still lifes often of a very primitive but bold nature.

1929. Birth of Kate. Exhibits in the Seven and Five Society exhibition.

1930. Spends some time in Paris at the time of his joint exhibition with Christopher Wood at Galerie Bernheim Jeune. Barbara Hepworth sees Nicholson's work for the first time at his one-man show at the Lefevre Gallery. Death of Christopher Wood.

1931. Birth of Andrew Nicholson. Nicholson moves to London and marriage to Winifred comes under strain. Meets Hepworth. In the Summer Nicholson and Hepworth spend some weeks in Happisburgh, Norfolk with Henry Moore and Ivon Hitchens. Moves to Hampstead. Exhibits in the Seven and Five Society exhibition. Shares an exhibition with Barbara Hepworth and William Staite Murray at the Bloomsbury Gallery, London.

1932. Begins to share a studio in Hampstead with Hepworth in the Mall, behind Parkhill Road. In the Spring they travel to France visiting the studios of Arp and Brancusi, spending Easter at Avignon and St Rémy. On their return they visit Picasso at the Château Boisgeloup, Gisors. In the Summer they spend time with Braque in Dieppe and visit Calder, Miró and Giacometti in Paris. Paints *1932 (Au Chat Botté)*. In December Winifred moves with her children into an apartment at 48 Quai d'Auteuil, Paris. Nicholson exhibits in the Seven and Five Society exhibition and holds a one-man show at the Lefevre Gallery. At the end of the year he shares a show with Barbara Hepworth at Arthur Tooth and Sons, London.

1933. Spends the summer in Paris visiting Winifred and the children. Introduced by Moholy-Nagy to Mondrian. Hélion invites Nicholson and Hepworth to join Abstraction-Création. Returns to Paris in December to visit Winifred and the children and makes the first reliefs. Winifred has a wide circle of friends who are at the centre of the abstract movement. Exhibits in the Seven and Five Society exhibition and shares an exhibition at the Lefevre Gallery with Barbara Hepworth. Exhibits in the permanent exhibition of Abstraction-Création. Makes a significant number of linocuts which display the range of his styles. Some of these are printed on fabric by Nancy Nicholson.

1934. Visits Mondrian in his studio in the rue du Départ. By March the reliefs are painted white and employ a vocabulary of geometric shapes. Marries Hepworth and in October she gives birth to triplets Sarah, Rachel and Simon (died 1990). Exhibits in the Seven and Five Society exhibition and the *Unit 1* exhibition.

1935. Final exhibition of the Seven and Five Society which is devoted exclusively to abstract art owing to pressure from Nicholson and John Piper, who by then was the secretary of the society. Exhibits in *Thèse, anithèse, synthèse* at the Kunstmuseum, Lucerne, the *Exposition internationale d'art moderne*, Brussels and *Artists against Fascism* in London. Holds one-man show at Lefevre Gallery. From now on Nicholson holds one-man shows with regularity in commercial galleries in England.

1936. Meets Naum Gabo and J.L. (Leslie) Martin at *Abstract and Concrete* exhibition organised by Nicolete Gray which included the work of Mondrian, Kandinsky, Arp, Nicholson, Hepworth and Hélion among others. This exhibition started in Oxford and then toured to further venues in England. Exhibited in *Cubism and Abstract Art* at the Museum of

Modern Art, New York organised by Alfred H. Barr and in *Twee Eeuwen Engelsche Kunst* at the Stedelijk Museum, Amsterdam. Plans for *Circle* initiated.

1936–39. Arrival of many of the leading architects and artists from the Continent seeking refuge from political unrest and Fascism. These include Gabo, Moholy-Nagy, Breuer, Gropius, Mondrian and Lubetkin.

1937. Publication of *Circle* edited by Naum Gabo, Leslie Martin and Ben Nicholson with help from Barbara Hepworth and Sadie Martin. Holiday with Hepworth at Varangeville. Braque and Miró stay nearby.

1938. Exhibits in *Abstrakte Kunst* exhibition at the Stedelijk Museum, Amsterdam.

1939. Shortly before war declared Nicholson and Hepworth take their children to Cornwall to stay as guests of Adrian Stokes at Little Park Owls in Carbis Bay. The Gabos soon join them. The change of environment has an immediate impact on Nicholson's work in which he reintroduces landscape colours. End of the year the Nicholsons move to a house named Dunluce.

1939–45. Spends the war years making small projects and drawing. Executes both abstract and figurative works, the latter often depictions of Cornish scenes. During this time becomes the senior figure in a circle of younger artists who live in the area and who are working in avant-garde ways.

1941. Publishes 'Abstract Notes' in *Horizon* edited by Cyril Connolly.

1942. The Nicholsons move to Chy-an-Kerris on the far side of Carbis Bay which gives Nicholson more room in which to work.

1943. Publishes an article on Alfred Wallis in *Horizon* after Wallis's death in 1942. Joins the St Ives Society of Artists and exhibits with them the following year and regularly thereafter until 1949.

1944. Retrospective exhibition held at Leeds City Art Gallery (Temple Newsam House).

1945. Stops making abstract reliefs and concentrates on painting still lifes and abstract paintings based on still life.

1947. First of two volumes edited by Herbert Read on Nicholson's art published by Lund Humphries.

1949. Penwith Society of Arts in Cornwall founded. Ben Nicholson was a founder member. Herbert Read invited to be President. First exhibition of the Penwith Society of Arts. Nicholson exhibits regularly with the Society thereafter until he leaves St Ives. Moves to new studio behind Porthmeor Beach, St Ives which permits him to work on a larger scale. The studio has skylights but no windows onto the sea. Commissioned by Easton and Robertson to decorate two concave panels for the steamship *Rangitania* of the New Zealand Shipping Company. This leads to a series of curved panel paintings.

1950. Begins fairly regular trips to Italy and other Mediterranean countries on which he makes numerous drawings of architectural monuments and landscape.

1951. Commissioned to paint mural for the Festival of Britain in the Regatta Restaurant, South Bank, London. Nicholson and Hepworth divorce. Nicholson moves to Trezion on Salubrious Place, St Ives.

1952. Awarded the first prize for painting at the *39th International Exhibition* (Carnegie International) for *December 5, 1949 (poisonous yellow)*. Retrospective held at the Detroit Institute of Arts and the Walker Arts Center, Minneapolis. Commissioned to paint a mural for the Time-Life building, New Bond Street, London.

1953. Exhibits in the third Fitzroy Street exhibition organised by the artist Adrian Heath. Other exhibitors include Kenneth and Mary Martin, Victor Pasmore, William Scott, Roger Hilton, Eduardo Paolozzi, Terry Frost and Robert Adams.

September 1961 (Paros Chapel). Oil, wash and pencil on paper, 15 3/4 × 19 1/2 in (40 × 49.5 cm). Trustees of the Tate Gallery.

1954. Retrospective at the Venice Biennale. Exhibition travelled to Amsterdam, Paris and Zurich. Receives the Ulisse award.

1955. Retrospective at the Tate Gallery, London. Receives the Governor of Tokyo award at the *3rd International Exhibition*, Japan.

1956. Awarded Grand Prix at the fourth *Mostra Internazionale de Bianco e Nero*, Lugano and First Guggenheim International painting prize for *August 1956 (Val d'Orcia)*. Second volume of book on Nicholson's work, edited by Herbert Read, published by Lund Humphries.

1957. First prize for painting at the *IV São Paulo Bienal*. Nicholson resigns membership of the Penwith Society of Arts. Marries Felicitas Vogler, a professional photographer.

1958. Leaves St Ives for the Ticino, Switzerland. Towards the end of the decade Nicholson returns to making reliefs often on a very large scale which, by the mid sixties, become his exclusive preoccupation apart from graphic works.

1961. Retrospective held at the Kunsthalle, Berne.

1964. Designed a wall for *Dokumenta III* at Kassel. Retrospective held at the Museum of Fine Arts, Dallas.

1965–68. Makes a series of etchings with François Lafranca.

1968. Awarded the Order of Merit by Her Majesty Queen Elizabeth II.

1969. Thames and Hudson publish a major book on Nicholson with an introduction by John Russell, then art critic of the *Sunday Times*. Major retrospective held at the Tate Gallery, London.

1971. Nicholson separates from Felicitas Vogler and moves from the Ticino to Cambridge where he stays with Sir Leslie and Sadie Martin in Great Shelford. From this year until his death Nicholson concentrates principally on drawing owing to deteriorating health.

1974. Receives the Rembrandt Prize from the Johann Wolfgang von Goethe Foundation. Moves back to Hampstead, London.

1978. Retrospective exhibition held at the Albright-Knox Art Gallery, Buffalo which travelled to the Hirshhorn Museum and Sculpture Garden, Washington DC and the Brooklyn Museum, New York.

1982. Dies on 6 February in London.

Selected Bibliography

Articles and Statements by Ben Nicholson

'The Aims of the Modern Artist', *Studio*, vol. 104, December 1932.

Untitled statement in Read, Herbert (ed.), *Unit 1: The Modern Movement in English Architecture, Painting and Sculpture*, Cassell, London 1934.

Untitled statements in Martin, J.L., Nicholson, Ben and Gabo, N. (eds.), *Circle: International Survey of Constructive Art*, Faber and Faber, London 1937.

'Notes on Abstract Art', *Horizon*, vol. 4, no. 22, October 1941.

'Notes on Abstract Art' in Guggenheim, Peggy (ed.), *Art of this Century*, Art of this Century, New York 1942.

Berlin, Sven and Nicholson, Ben, 'Alfred Wallis', *Horizon*, vol. 7, no. 37, January 1943.

'Defending Modern Artists', *Daily Mail*, 7 August 1951.

Untitled statements in *Ben Nicholson: A Retrospective Exhibition*, exhibition catalogue, Tate Gallery, London 1955.

Untitled statements in *Statements: A Review of British Abstract Art in 1956*, Institute of Contemporary Arts, London 1956.

'Architecture and the Artist', *The Architects Journal*, 16 January 1958.

'Mr. Ben Nicholson Answers Some Questions about his Work and Views', *Times*, 12 November 1958.

'More or Less about Abstract Art: A Reply to Victor Pasmore', *London Magazine*, vol. 1, no. 4, July 1961.

Untitled statement in Baxandall, David, *Ben Nicholson*, Methuen, London 1962.

Interview with Vera and John Russell, 'The Life and Opinions of an English 'Modern', *Sunday Times*, 23 April 1963.

'Mondrian in London', *Studio International*, vol. 172, December 1966.

Untitled Statements in *Ben Nicholson*, exhibition catalogue, Galerie Beyeler, Basle 1968.

'Tribute to Herbert Read', *Studio International*, vol. 177, January 1969.

Extracts from letters in Sausmarez, Maurice de (ed.), *Ben Nicholson*, Studio International (special number), London 1969.

Books and Articles on Ben Nicholson

Abadie, Daniel, 'Ben Nicholson on l'éloge de la modestie', *Hommage à Ben Nicholson (1894–1982)*, exhibition catalogue, Galerie Marwan Hoss, Paris 1990.

Alley, Ronald, *Ben Nicholson*, Express Books, London 1962.

Anon., *Art in Britain 1930–40 Centred around Axis, Circle Unit One*, exhibition catalogue, Marlborough Fine Art, London 1965.

Baxandall, David, *Ben Nicholson*, Methuen, London 1962.

Harrison, Charles, 'Abstract Painting in Britain in the Early 1930s', *Studio International*, vol. 173, April 1967.

Harrison, Charles, *Ben Nicholson*, exhibition catalogue, Tate Gallery, London 1969.

Harrison, Charles, *English Art and Modernism 1900–1939*, Allen Lane, London and Indiana University Press, Indiana 1981.

Heron, Patrick, *The Changing Forms of Art*, Routledge and Kegan Paul, London 1955.

Hodin, J.P., *Ben Nicholson—The Meaning of his Art*, Alec Tiranti, London 1957.

Lewison, Jeremy (ed.), *Circle: Constructive Art in Britain 1934–40*, exhibition catalogue, Kettle's Yard Gallery, Cambridge 1982.

Lewison, Jeremy, *Ben Nicholson: The Years of Experiment 1919–39*, exhibition catalogue, Kettle's Yard Gallery, Cambridge, 1983.

Lewison, Jeremy, 'The Early Prints of Ben Nicholson', *Print Quarterly*, vol. 2, June 1985.

Lewison, Jeremy, *Ben Nicholson*, exhibition catalogue, Fundación Juan March, Madrid and Fundação Calouste Gulbenkian, Lisbon 1987.

Martin, J.L., Nicholson, Ben and Gabo, N. (eds.), *Circle. International Survey of Constructive Art*, Faber and Faber, London 1937.

Martin, J.L., 'Architecture and the Painter, with Special Reference to the Work of Ben Nicholson', *Focus*, no. 3, Spring 1939.

Moore, Helena (ed.), *The Nicholsons: A Story of Four People and their Designs*, exhibition catalogue, York City Art Gallery, 1988.

Nash, Paul, 'Ben Nicholson's Carved Reliefs', *Architectural Review*, vol. 78, October 1935.

Nash, Steven A., *Ben Nicholson: Fifty Years of his Art*, exhibition catalogue, Albright-Knox Art Gallery, Buffalo, New York 1978.

Nicholson, Andrew (ed.), *Unknown Colour. Paintings, Letters, Writings by Winifred Nicholson*, Faber and Faber, London 1987.

Piper, Myfanwy, 'Back in the Thirties', *Art and Literature*, no. 7, Winter 1965.

Read, Herbert, 'Ben Nicholson's Recent Work', *Axis*, no. 2, April 1935.

Read, Herbert, 'Ben Nicholson and the Future of Painting', *Listener*, vol. 14, 9 October 1935.

Read, Herbert (ed.), *Ben Nicholson: Paintings, Reliefs, Drawings*, Lund Humphries, London 1948: Reprinted in 1955 as *Ben Nicholson: Work from 1911–1948*, vol. 1.

Read, Herbert (ed.), *Ben Nicholson: Work since 1947*, vol. 2, Lund Humphries, London 1956.

Read, Herbert, 'A Nest of Gentle Artists', *Apollo*, vol. 76, September 1962.

Russell, John, *Ben Nicholson: Drawings, Paintings and Reliefs 1911–68*, Thames and Hudson, London 1968.

Saumsmerez, Maurice de (ed.), *Ben Nicholson*, Studio International (special number), London 1969.

Summerson, John, *Ben Nicholson*, Penguin Books, London 1948.

Tschichold, Jan, 'On Ben Nicholson's Reliefs', *Axis*, no. 2, April 1935.

ILLUSTRATIONS

1919 (blue bowl in shadow).
Oil on canvas,
19 × 25 ½ in. (48.2 × 64.7 cm).
Private collection, courtesy Browse and Darby Limited, London.

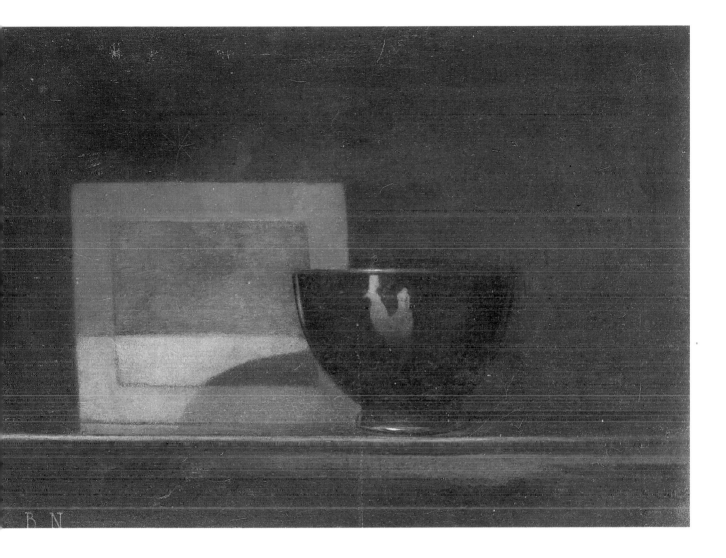

2. *1917 (portrait of Edie).*
 Oil on canvas,
 18 ½ × 14 in. (47 × 35.6 cm).
 Sheffield City Art Galleries.

3. *1922 (bread).*
 Oil on canvas,
 27 × 29 ¾ in. (68.5 × 75.6 cm).
 Private collection.

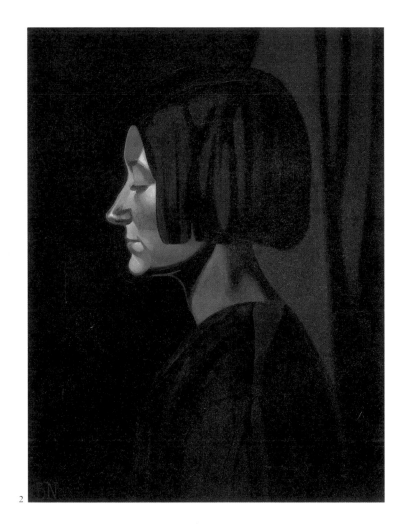

2

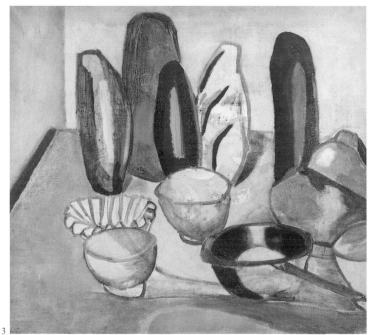

3

4. *c. 1922 (Balearic Isles).*
 Oil and pencil on canvas,
 23 ¹/₂ × 21 ¹/₂ in. (59.6 × 54.6 cm).
 Kettle's Yard, University of Cambridge.

5. *1921-2 (still life - Villa Capriccio-Castagnola).*
 Oil on canvas,
 24 ³/₈ × 29 ¹/₂ in. (62 × 75 cm).
 Private collection.

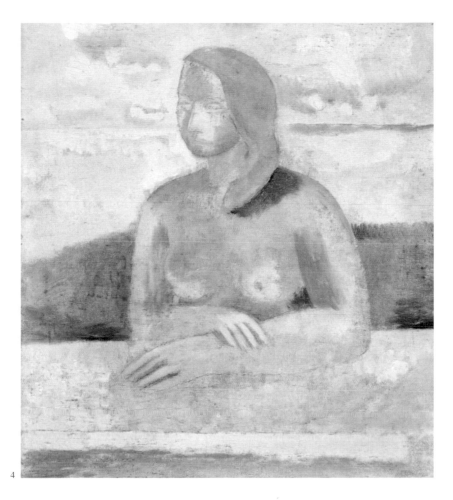

4

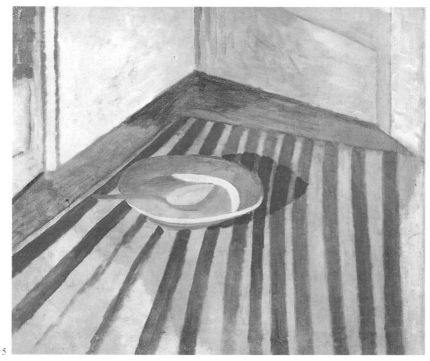

5

6. *1921-c. 1923 (Cortivallo, Lugano).*
Oil and pencil on canvas,
18 × 24 in. (45.7 × 61 cm).
Trustees of the Tate Gallery.

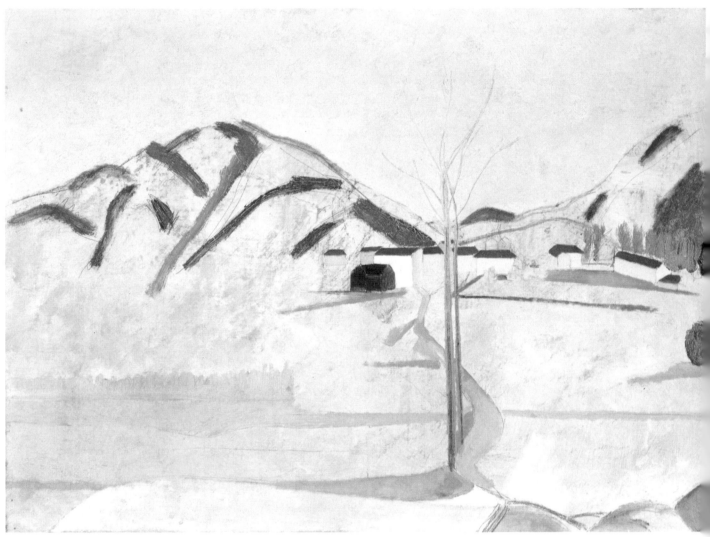

6

7. *1922 (coast of Spain).*
 Oil on board,
 16 × 18 ⅛ in. (40.5 × 46 cm).
 Private collection.

8. *1923 (Dymchurch).*
 Oil on canvas mounted on board,
 11 ⅜ × 15 ⅛ in. (29 × 38.5 cm).
 Private collection.

7

8

9. *1924 (first abstract painting, Chelsea).*
 Oil and pencil on canvas,
 21 ¾ × 24 ⅛ in. (55.4 × 61.2 cm).
 Trustees of the Tate Gallery.

10. *1924 (abstract painting - [?] Andrew).*
 Oil and sand on canvas,
 25 × 29 ⅞ in. (63.5 × 76 cm).
 Private collection.

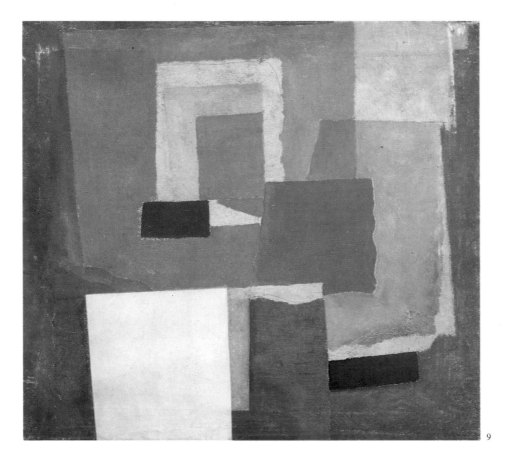

9

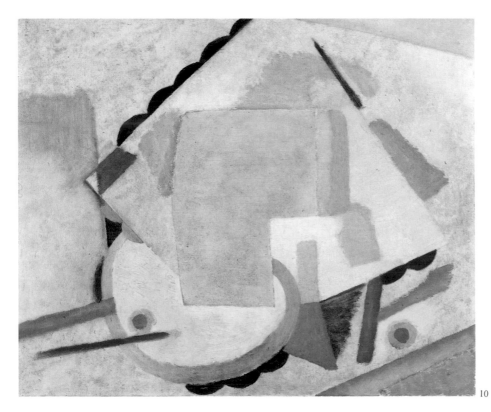

10

11. *1924 (trout).*
Oil on canvas,
22 × 23 in. (56 × 58.5 cm).
Private collection.

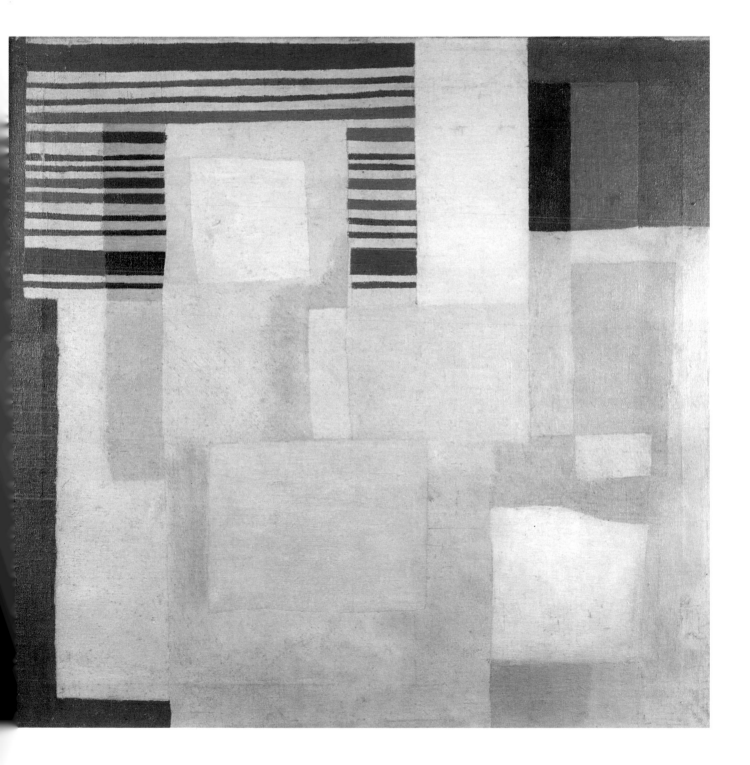

12. *1924 (bottle and goblet).*
Oil and pencil on board,
11 ½ × 17 ⅝ in. (29.1 × 44.8 cm).
Kettle's Yard, University of Cambridge.

13. *1924 (still life - bottle and goblets).*
Oil on canvas,
21 ⅞ × 30 ⅛ in. (55.5 × 76.5 cm).
Private collection.

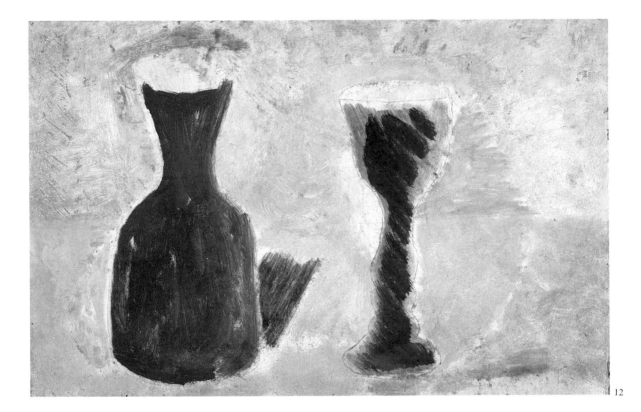

12

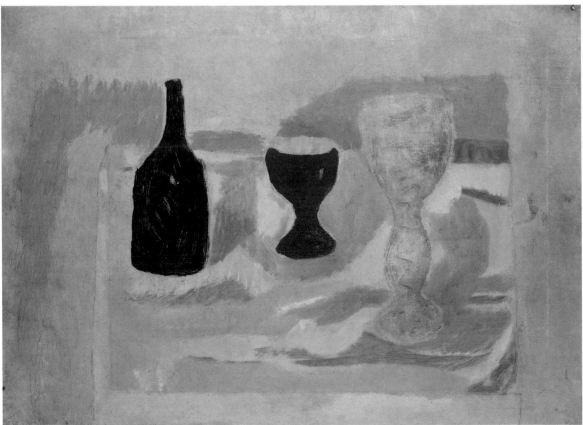

13

14. *1924 (goblet and two pears).*
 Oil and pencil on board,
 $14\,^5/_8 \times 17\,^1/_2$ in. $(37 \times 44.5$ cm$)$.
 Kettle's Yard, University of Cambridge.

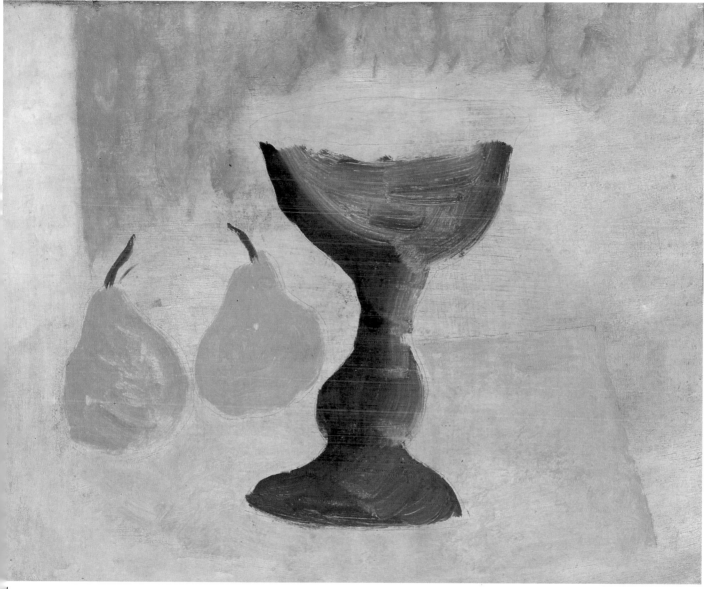

4

15. *1925 (still life with jug, mugs, cup and goblet).*
Oil and pencil on canvas,
$23\,^{5}/_{8} \times 23\,^{5}/_{8}$ in. $(60 \times 60$ cm$)$.
Helen Sutherland Collection.

16. *1925 (still life - Balearic Islands).*
Oil and pencil on canvas,
$26\,^{3}/_{8} \times 29\,^{1}/_{2}$ in. $(67 \times 75$ cm$)$.
Ivor Braka Limited, London.

15

16

17. *1925-6 (snowscape)*.
Oil on canvas,
19 ½ × 30 ⅞ in. (49.5 × 78.4 cm).
Kettle's Yard, University of Cambridge.

18. *1925 (landscape from Bankshead studio looking east)*.
Oil on canvas,
20 ⅛ × 29 ⅞ in. (51 × 76 cm).
Private collection.

17

18

19. *c. 1926 (apples).*
Oil and pencil on canvas,
17 1/4 × 26 5/8 in. (43.9 × 67.5 cm).
Kettle's Yard, University of Cambridge.

20. *1926 (still life with fruit - version 2).*
Oil on canvas,
21 3/4 × 24 in. (55.2 × 61 cm).
The British Council.

21. *1927 (Winifred and Jake).*
Oil and pencil on canvas,
27 1/8 × 27 1/8 in. (69 × 69 cm).
Private collection.

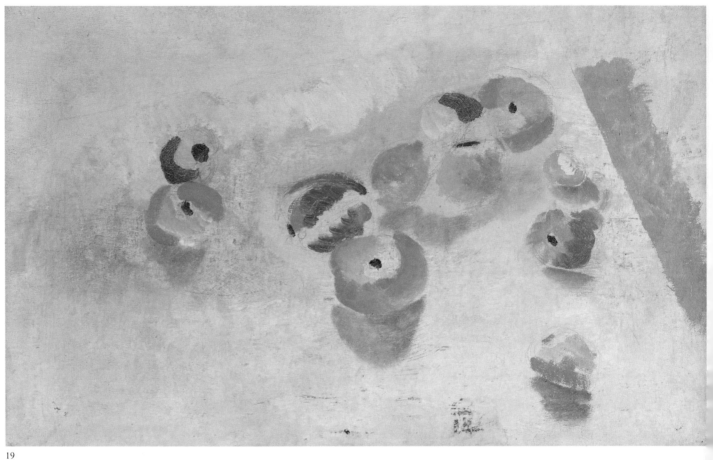

19

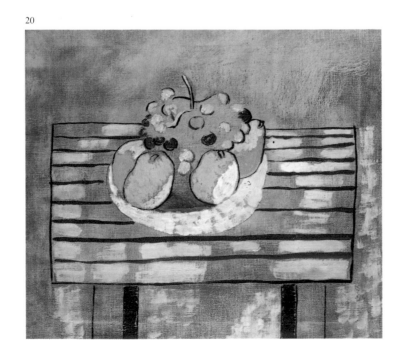

20

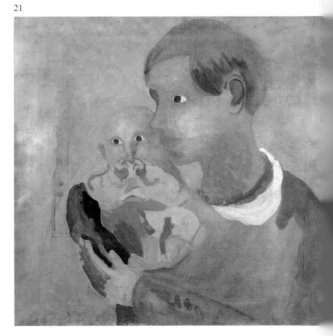

21

22. *May 1927 (still life with knife and lemon).*
 Oil on canvas,
 17 ½ × 27 in. (44.5 × 68.5 cm).
 Kettle's Yard, University of Cambridge.

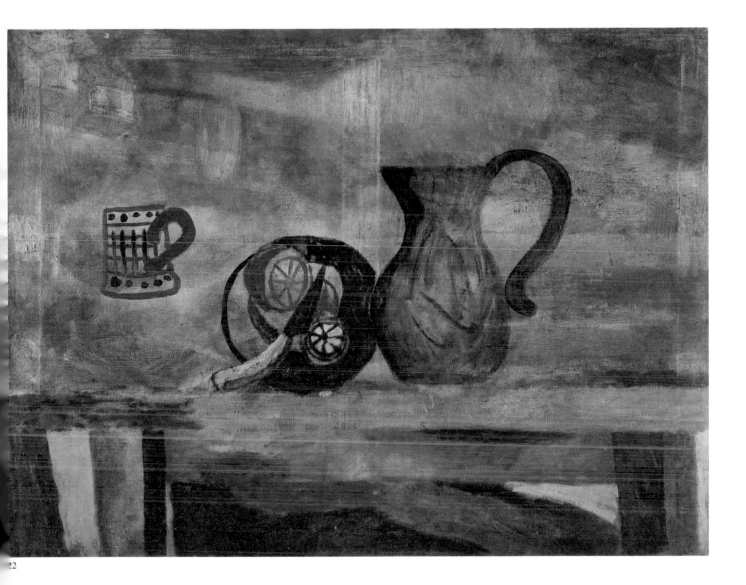

23. *c. 1927 (still life).*
 Oil on canvas,
 21 ¼ × 26 in. (54 × 66 cm).
 Private collection.

24. *c. 1927 (flowers).*
 Oil on canvas,
 15 × 14 ⅝ in. (38 × 37 cm).
 Private collection.

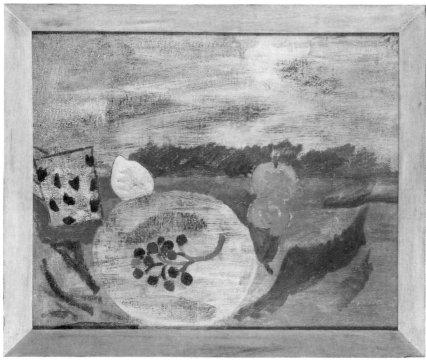

23

24

25. *1928 (Pill Creek).*
Oil, gesso and pencil on canvas,
19⅛ × 24 in. (48.5 × 61 cm).
Private collection.

26. *1928 (Pill Creek, moonlight).*
 Oil, gesso and pencil on canvas,
 19 ½ × 24 in. (49.5 × 61 cm).
 Helen Sutherland Collection.

27. *1928 (Porthmeor Beach, St Ives).*
 Oil and pencil on canvas,
 35 ½ × 47 ¼ in. (90 × 120 cm).
 Helen Sutherland Collection.

26

28. *1928 (Walton Wood cottage, no. 1).*
 Oil on canvas,
 22 × 24 in. (56 × 61 cm).
 Scottish National Gallery of Modern Art.

29. *1928 (foothills, Cumberland).*
 Oil on canvas,
 22 × 27 in. (55.9 × 68.6 cm).
 Trustees of the Tate Gallery.

28

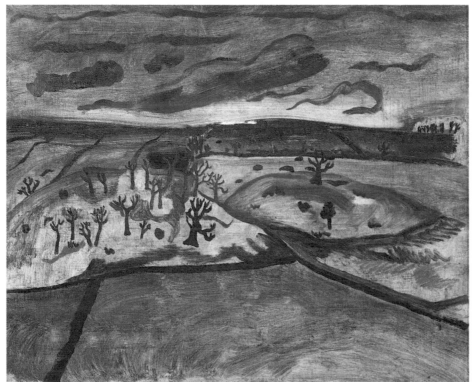

29

30. *1928 (Cornwall)*.
 Oil on canvas,
 8 ½ × 13 ½ in. (21.6 × 34.3 cm).
 Kettle's Yard, University of Cambridge.

31. *1928 (Cumbrian landscape)*.
 Oil on canvas,
 17 ¾ × 21 ⅞ in. (45.2 × 55.5 cm).
 Kettle's Yard, University of Cambridge.

30

31

32, 33. *1928-9 (painted box).*
Oil on wood,
13 × 11 × 5 in. (33 × 28 × 12.7 cm).
Browse and Darby Limited, London.

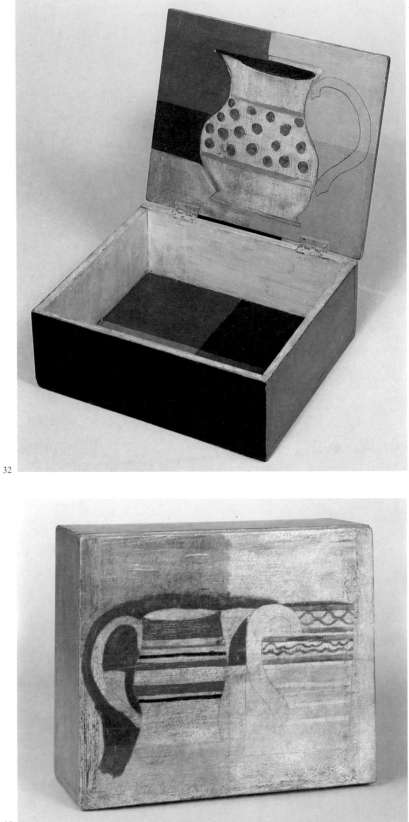

32

33

34. *1929 (Holmhead, Cumberland).*
Oil on canvas,
20 × 30 in. (50.8 × 76.2 cm).
Private collection.

35. *1929 (pomegranate).*
Oil and gesso on canvas mounted on board,
16 × 23 ⅞ in. (40.5 × 60.5 cm).
Helen Sutherland Collection.

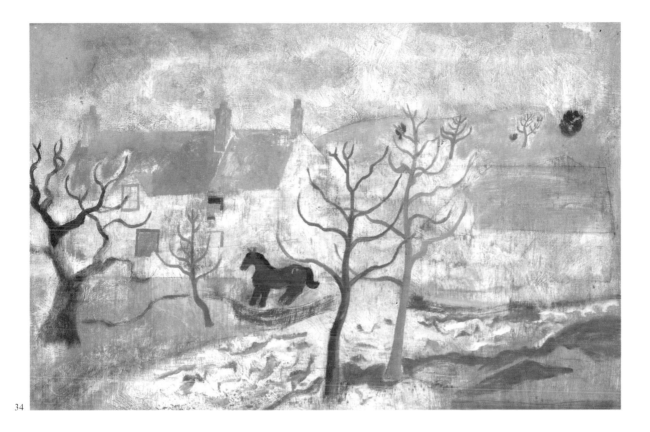

34

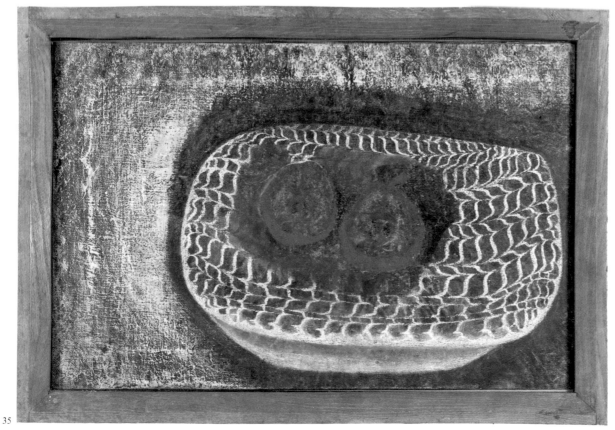

35

36. *1929 (still life - jug and playing cards).*
 Oil on canvas,
 27 × 34 ½ in. (68.5 × 87.5 cm).
 Ivor Braka Limited, London.

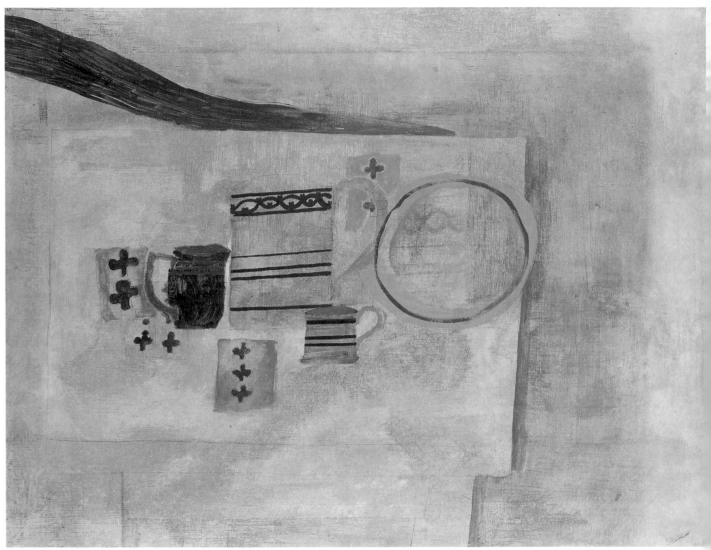

36

37. *1929 (fireworks).*
 Oil on board,
 11 ⁷⁄₈ × 18 ⅛ in. (30 × 46 cm).
 The Pier Gallery, Stromness, Orkney.

38. *1930 (still life with jug and mugs).*
 Oil and pencil on board,
 14 ⁷⁄₈ × 17 ½ in. (37.8 × 44.5 cm).
 Courtesy Bo Alveryd, Vaumarcus, Switzerland.

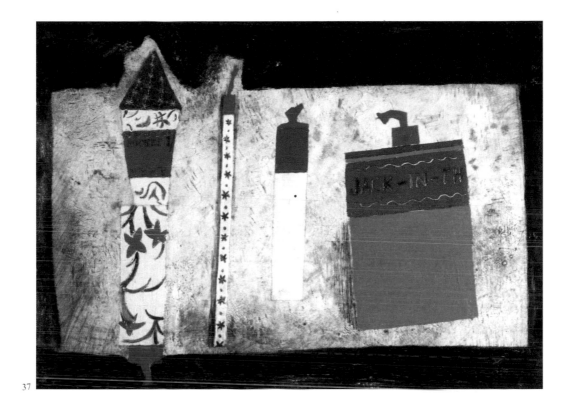

37

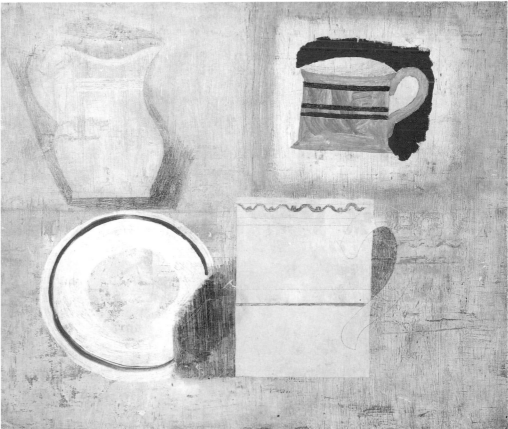

38

39. *1930 (Christmas night).*
 Oil and pencil on canvas,
 25 ⅛ × 36 ⅞ in. (63.7 × 93.7 cm).
 Kettle's Yard, University of Cambridge.

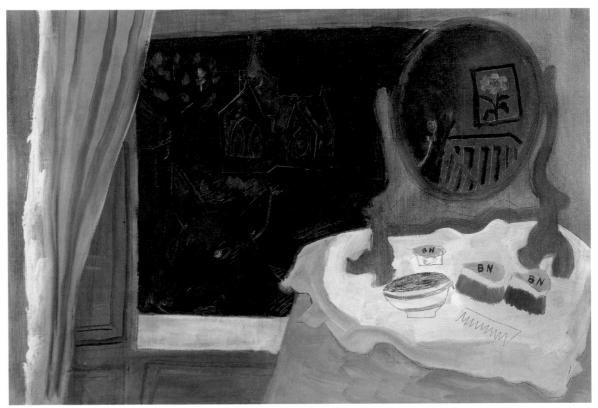

39

40. *1932 (profile - Venetian red).*
 Oil on canvas,
 50×36 in. (127×91.4 cm).
 Private collection.

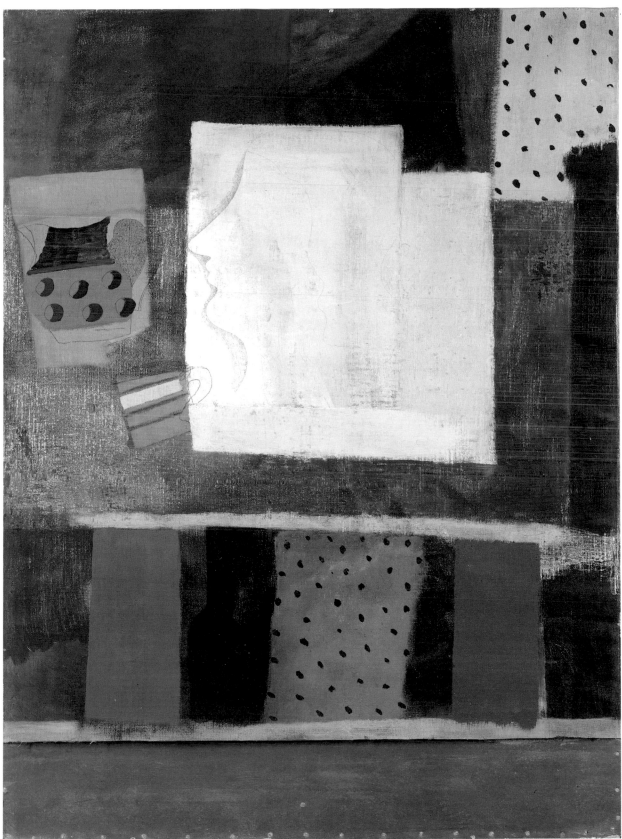

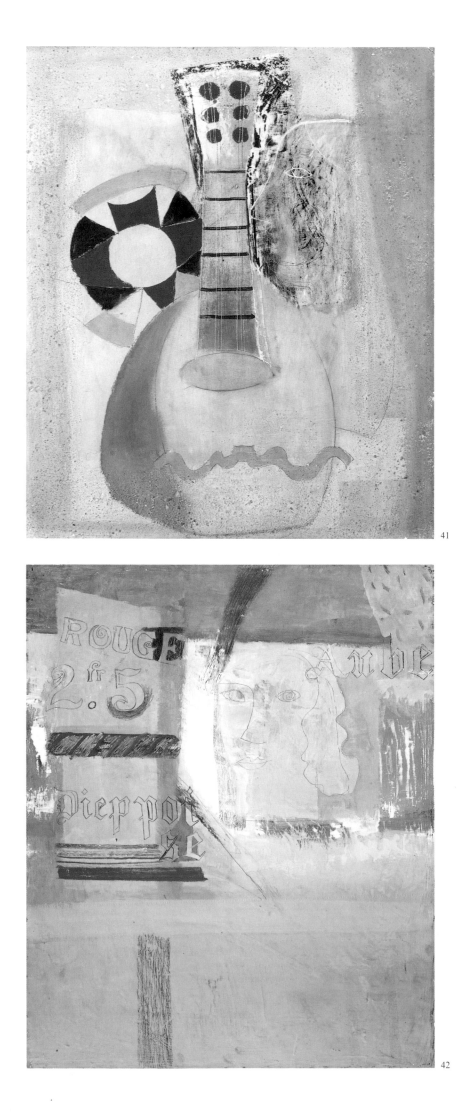

41

42

41. *c. 1932 (still life and guitar).*
 Oil, gesso, sand and pencil on board,
 30 × 24 ⅞ in. (76.2 × 63.3 cm).
 Leeds City Art Galleries.

42. *1932 (Auberge de la Sole Dieppoise).*
 Oil, gesso and pencil on board,
 35 ½ × 29 ½ in. (90 × 75 cm).
 Trustees of the Tate Gallery.

43. *1932 (still life - violin).*
 Oil and gesso on board,
 29 ½ × 24 in. (75 × 61 cm).
 Private collection.

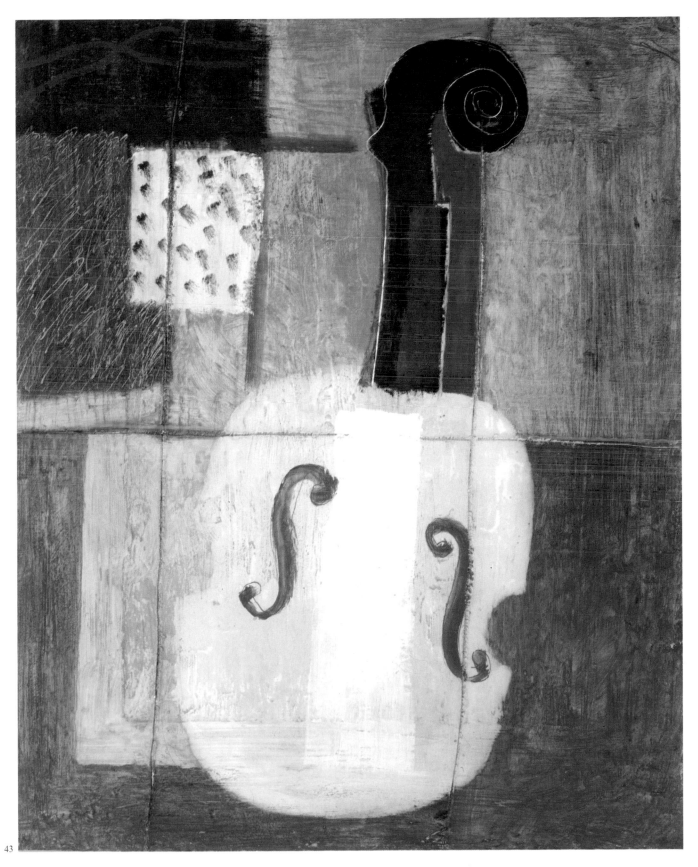

43

44. *1932 (Au Chat Botté).*
Oil and pencil on canvas,
36⅜ × 48 in. (92.5 × 122 cm).
Manchester City Art Galleries.

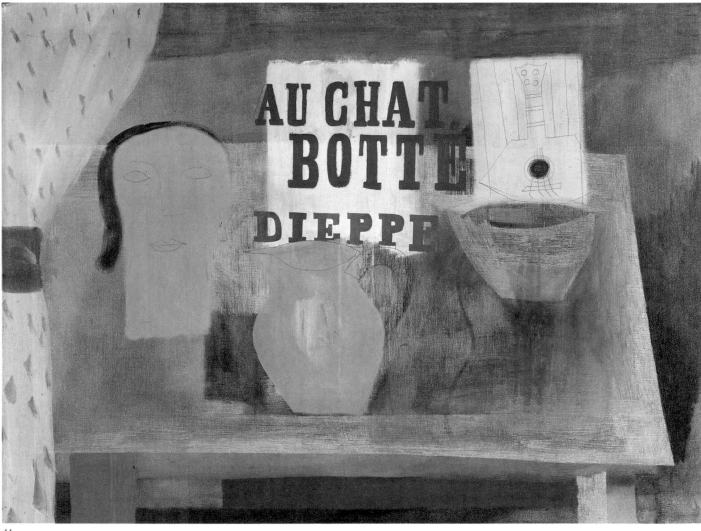

44

45. *1932 (Le Quotidien).*
Oil on canvasboard,
14 3/4 × 18 1/8 in. (37.5 × 46 cm).
Trustees of the Tate Gallery.

46. *1932 (crowned head - the queen).*
Oil on canvas mounted on board,
36 × 47 1/4 in. (91.4 × 120 cm).
Abbot Hall Art Gallery, Kendal.

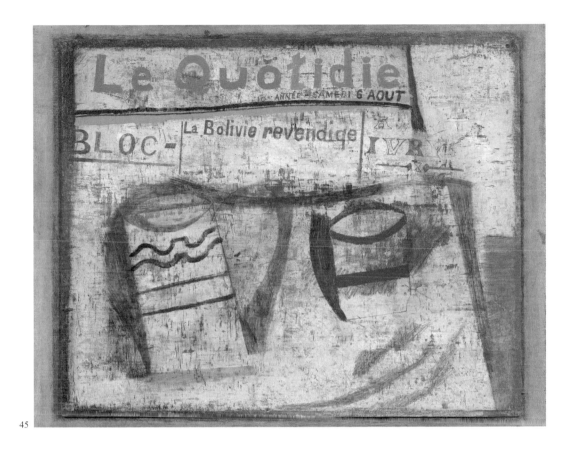

45

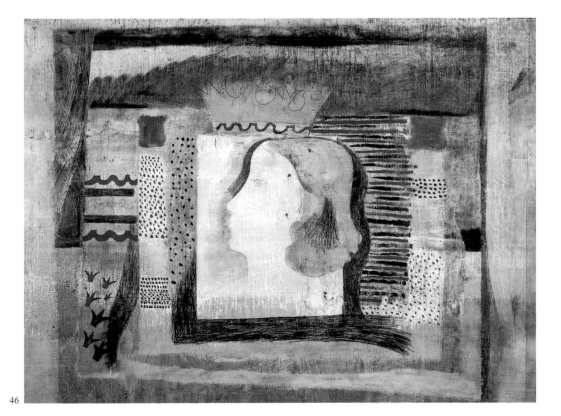

46

47. *1932 (prince and princess).*
Oil and pencil on board,
11 ⅝ × 18 ⅜ in. (29.5 × 46.7 cm).
Private collection.

48. *1932 (bocque).*
Oil and pencil on board,
18 ⅞ × 30 ⅞ in. (48 × 78.5 cm).
Arts Council of Great Britain.

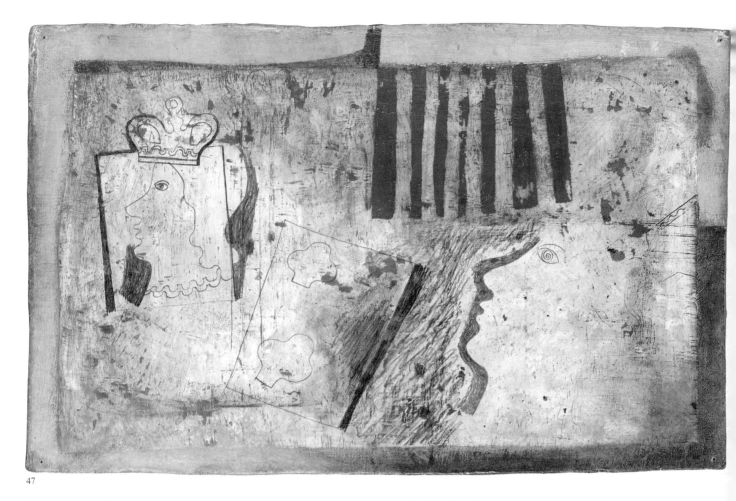

47

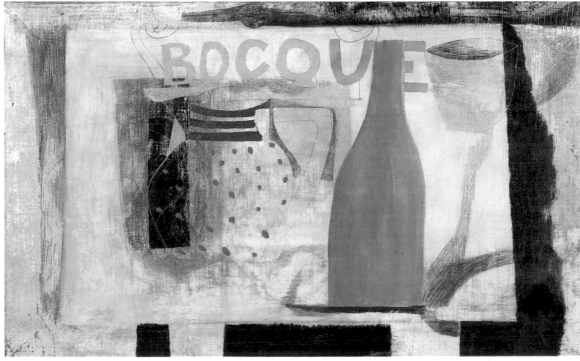

48

49. *1932-3 (musical instruments).*
Oil on board,
41 × 35 ½ in. (104 × 90 cm).
Kettle's Yard, University of Cambridge.

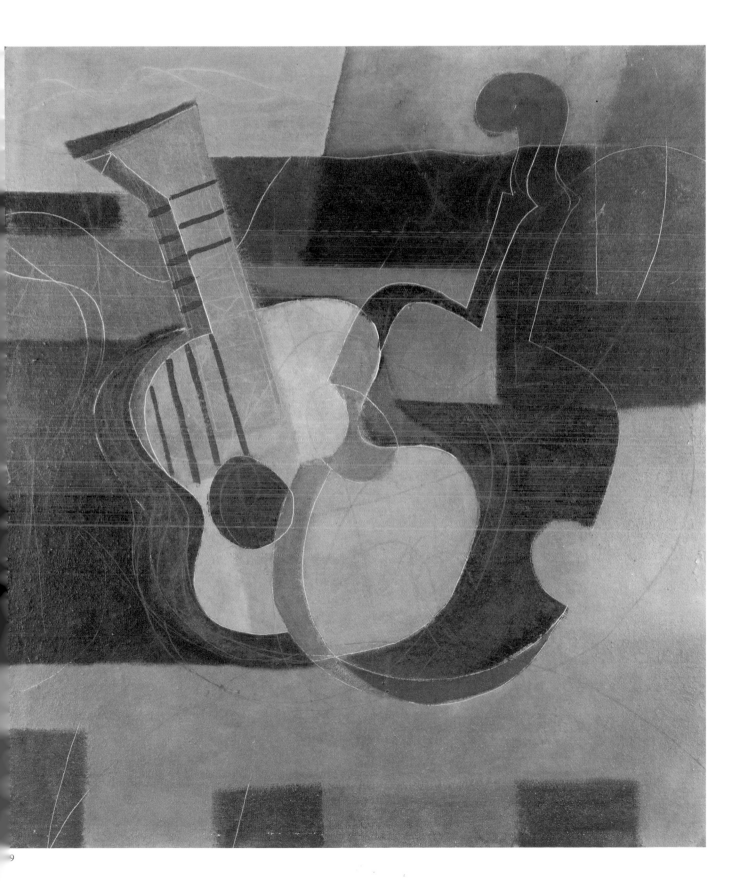

50. *1932 (painting).*
 Oil, gesso and pencil on canvas,
 29 1/8 × 47 1/4 in. (74 × 120 cm).
 Trustees of the Tate Gallery.

51. *1933 (coin and musical instruments).*
 Oil on canvas,
 41 1/2 × 47 3/4 in. (105.4 × 121.3 cm).
 Richard S. Zeisler Collection, New York.

50

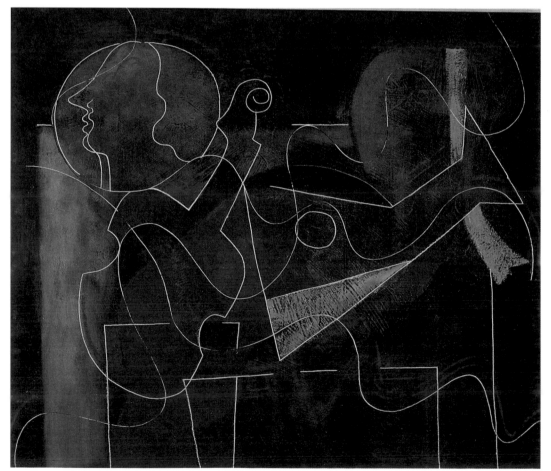

51

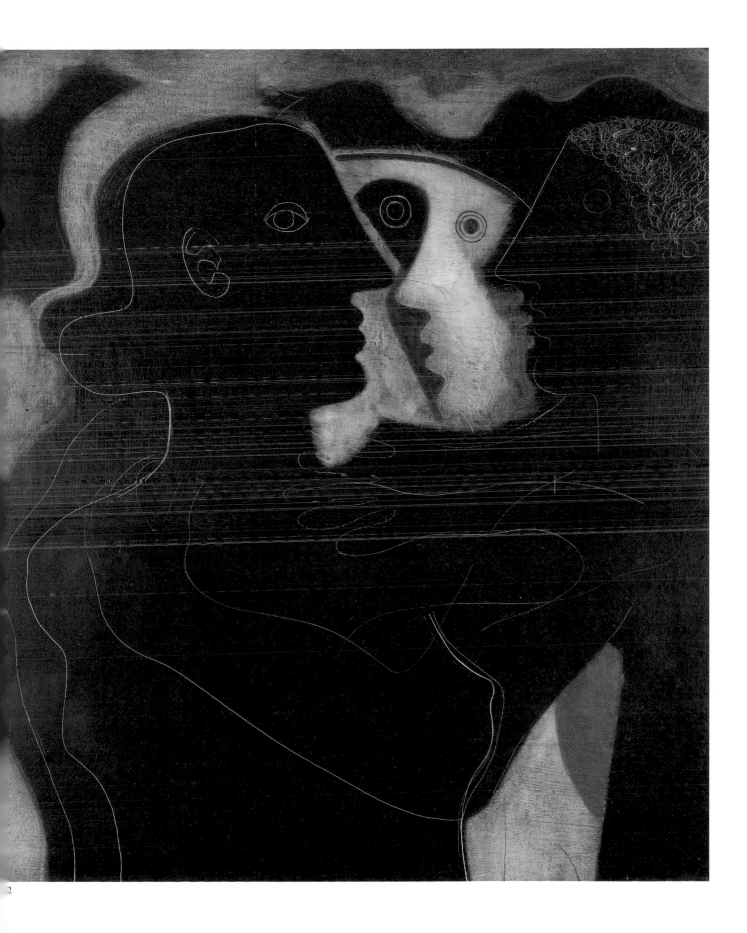

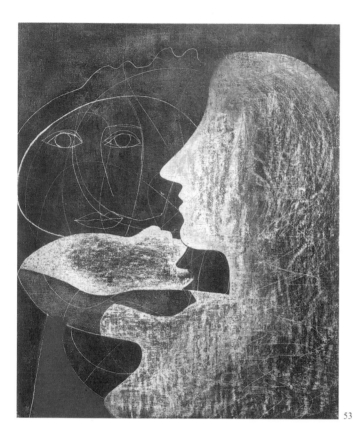

53

53. *1933 (girl at mirror).*
Oil and gesso on canvas mounted on board,
27 × 22 in. (68.6 × 55.9 cm).
Private collection.

54. *1933 (guitar).*
Oil and gesso on canvas,
26 3/8 × 21 1/8 in. (67 × 53.7 cm).
Kettle's Yard, University of Cambridge.

55. *1933 (milk and plain chocolate).*
Oil and gesso on board,
53 1/8 × 32 1/4 in. (135 × 82 cm).
Private collection.

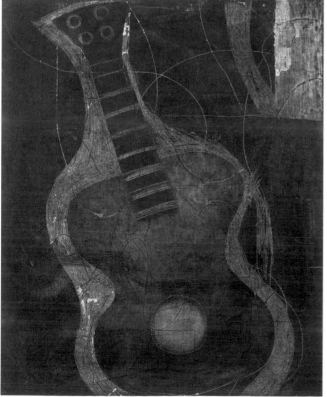

54

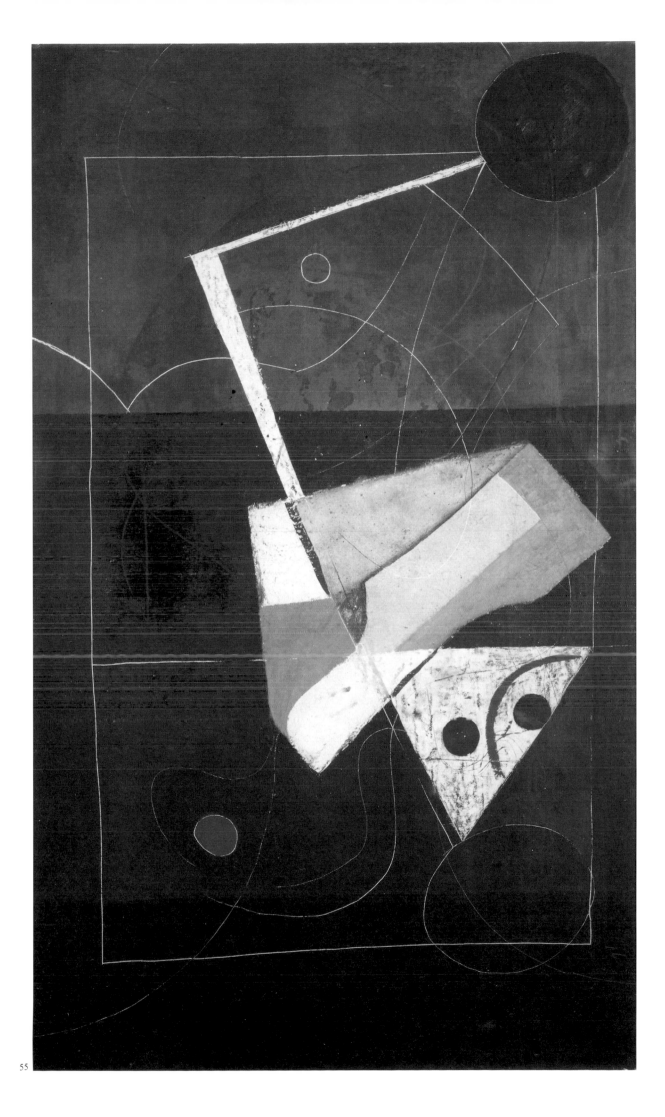

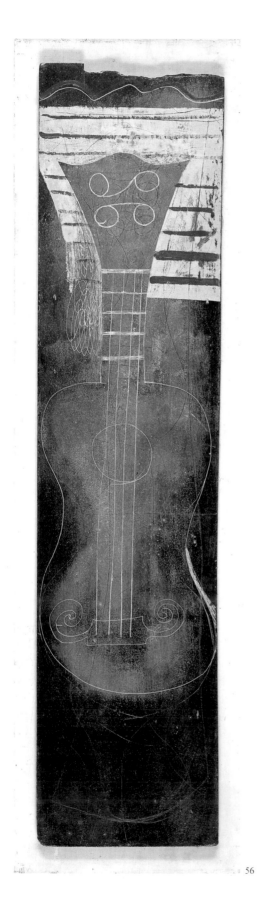

56. *1933 (guitar).*
Oil on panel mounted on board,
32 $\frac{5}{8}$ × 4 $\frac{1}{8}$ in. (83 × 10.5 cm)
on board 35 $\frac{1}{4}$ × 9 $\frac{7}{8}$ in. (89.5 × 25 cm).
Trustees of the Tate Gallery.

57. *1933 (collage with Spanish postcard).*
Oil and pencil with collage of paper and printed fabric on canvas,
19 $\frac{3}{4}$ × 29 $\frac{1}{2}$ in. (50 × 75 cm).
Ivor Braka Limited, London.

57

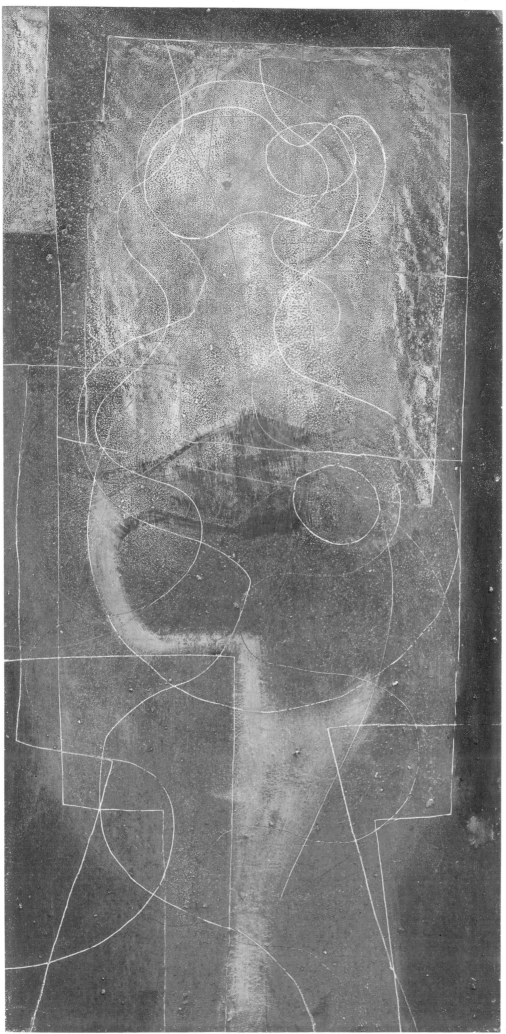

58. *1933 (composition in black and white).*
Oil and gesso on board,
45 × 22 in. (114.3 × 55.9 cm).
Borough of Thamesdown - Swindon Permanent
Art Collection.

59. *1933 (composition - hibiscus).*
Oil and gesso on canvas,
52 × 21 ⅞ in. (132 × 55.5 cm).
Ohara Museum of Art, Kurashiki, Japan.

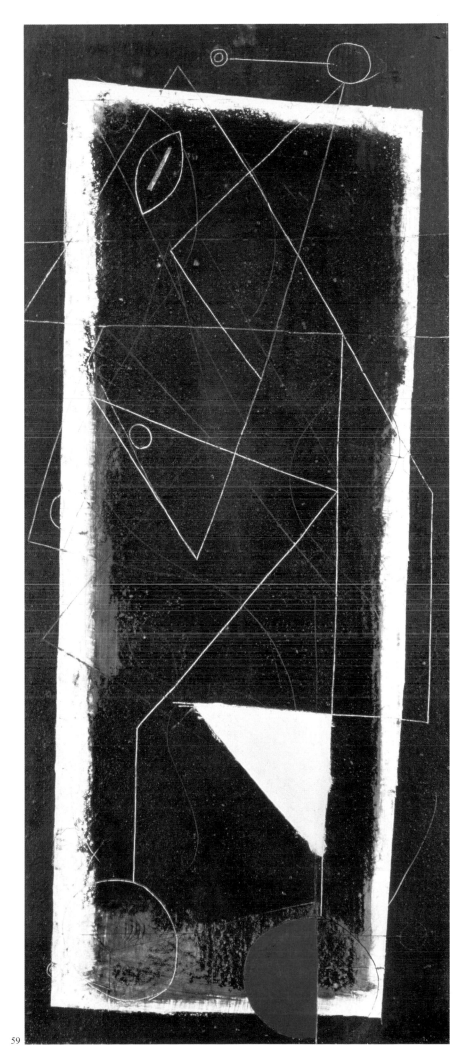

59

60. *1933 (painted relief).*
 Oil on carved board,
 17 3/8 × 11 3/8 in. (44 × 29 cm).
 Private collection.

61. *1933 (six circles).*
 Oil on carved board,
 45 × 22 in. (114.5 × 56 cm).
 Private collection.

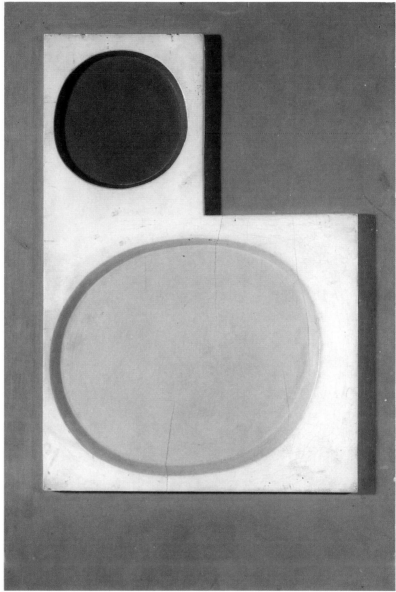

60

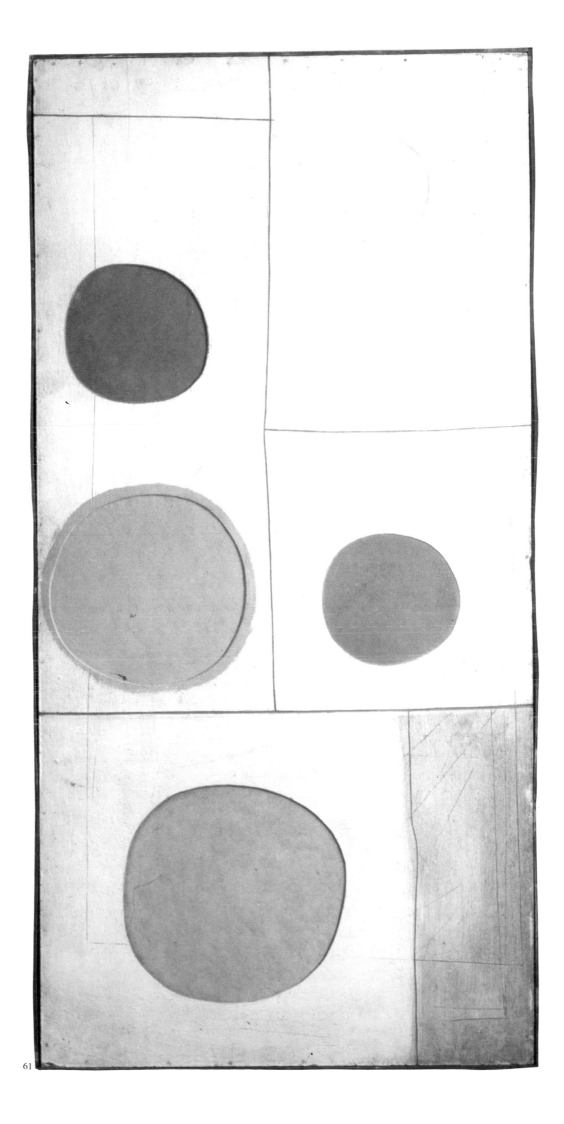

62. *1933 (red and lilac circle).*
Oil and pencil on board,
23 ¼ × 10 in. (59 × 25.5 cm).
Ivor Braka Limited, London.

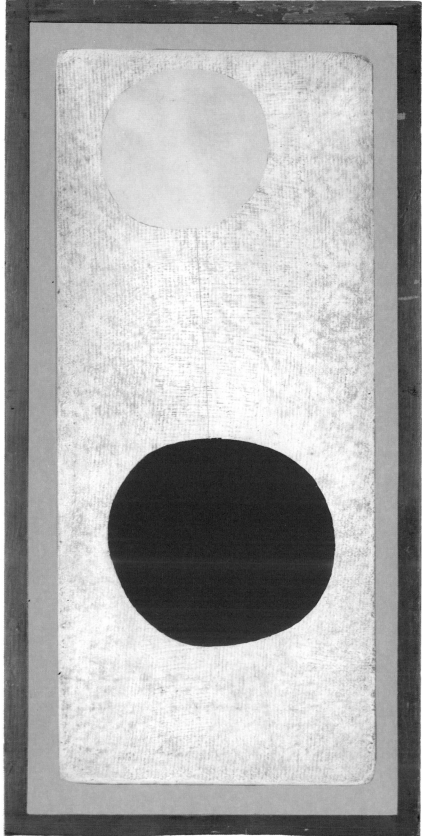

63. *1934 (painted relief)*.
Oil and pencil on carved board,
6 ⅛ × 6 ½ in. (15.5 × 16.5 cm).
Private collection.

64. *1934 (relief)*.
Oil on carved board,
4 × 4 in. (10 × 10 cm).
Kettle's Yard, University of Cambridge.

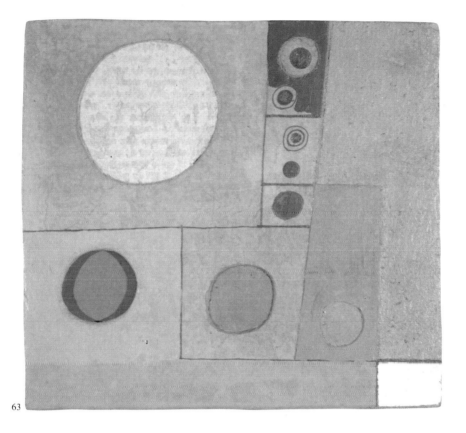

63

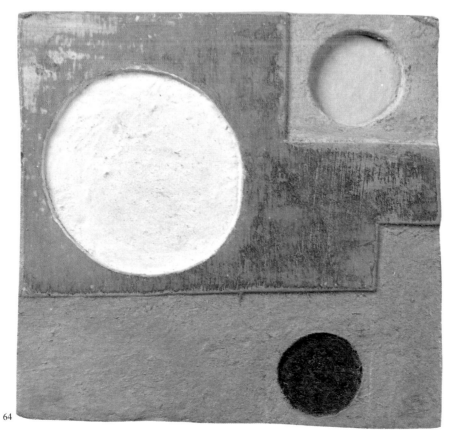

64

65. *Christmas 1933 (relief box).*
Oil on wood,
3 1/8 × 4 × 2 in. (8 × 10 × 5.2 cm).
Private collection.

66. *c. 1933 (bus ticket).*
Oil and pencil on board,
5/8 × 5 7/8 in. (1.5 × 14.8 cm).
Private collection.

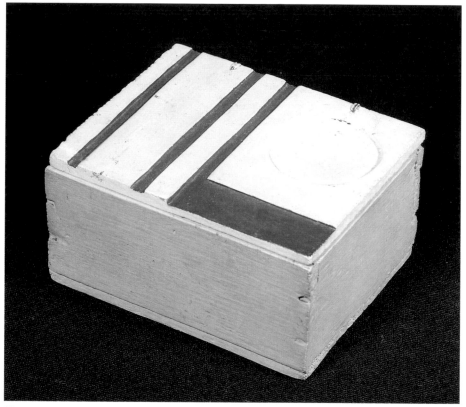

65

66

67. *1934 (relief).*
 Oil on carved board,
 28 ¼ × 38 in. (71.8 × 96.5 cm).
 Trustees of the Tate Gallery.

68. *1934 (painting)*.
 Oil on canvas,
 28 3/8 × 39 3/4 in. (72 × 101 cm).
 Kunstmuseum Düsseldorf.

69. *1934 (painting)*.
 Oil on board,
 14 5/8 × 17 3/4 in. (37 × 45 cm).
 The Pier Gallery, Stromness, Orkney.

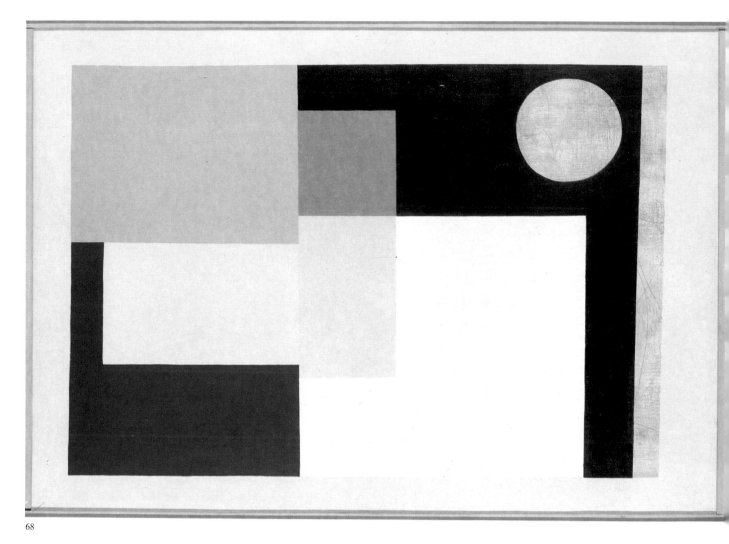

68

69

70. *1934 (white relief).*
 Oil on carved board,
 21 ½ × 31 ⅞ in. (54.5 × 81 cm).
 Ivor Braka Limited, London.

70

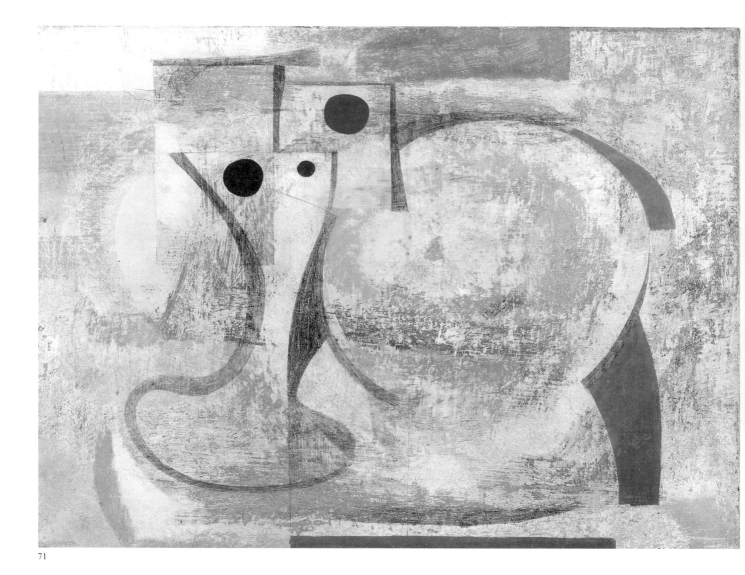

71

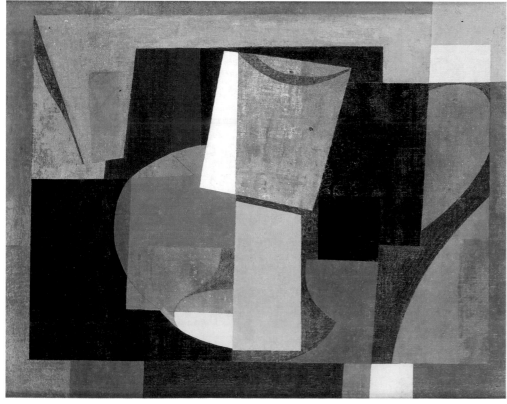

72

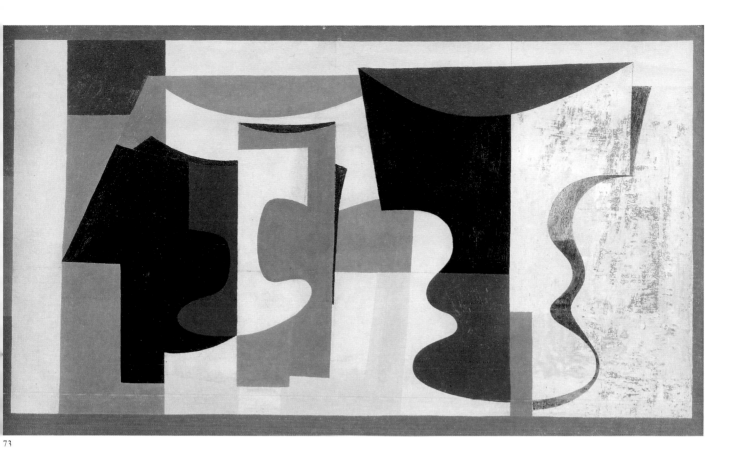

73

71. *1934 (still life, Birdie).*
 Oil on canvas,
 18 1/8 × 24 in. (46 × 61 cm).
 York City Art Gallery.

72. *1934-6 (painting - still life).*
 Oil and gesso on canvas,
 16 1/8 × 19 7/8 in. (41 × 50.6 cm).
 Private collection.

73. *1934 (Florentine ballet).*
 Oil and pencil on canvas,
 13 3/4 × 23 1/4 in. (35 × 59 cm).
 Private collection.

74. *1933-5 (still life with bottle and mugs).*
 Oil and gesso on board,
 19 1/2 × 23 3/8 in. (49.5 × 59.5 cm).
 Helen Sutherland Collection.

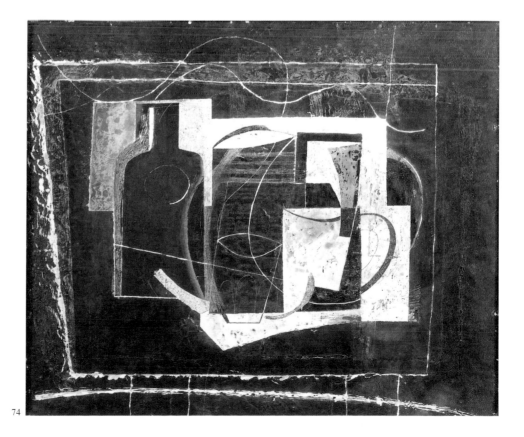

74

75. *1934 (white relief).*
Oil on canvas,
13 ¾ × 24 in. (34.9 × 61 cm).
Private collection.

77. *1935 (white relief).*
Oil on board,
21 ⅜ × 25 ¼ in. (54.4 × 64.2 cm).
Scottish National Gallery of Modern Art.

76. *1935 (painting).*
Oil on canvas,
23 ⅝ × 35 ⅞ in. (60 × 91 cm).
Private collection.

78. *1935 (painting).*
Oil on canvas,
40 × 41 ½ in. (101.6 × 105.4 cm).
Private collection.

75

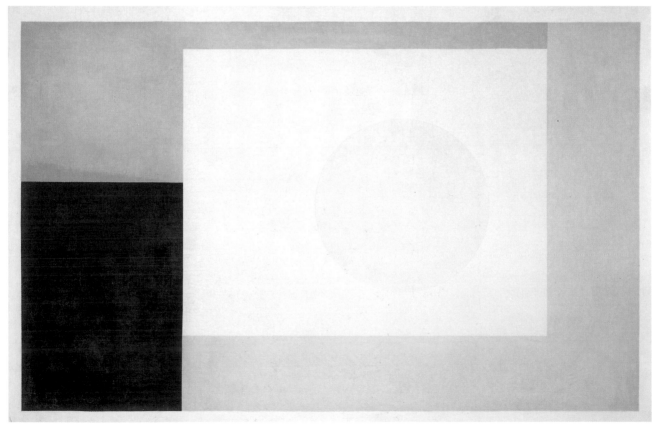

76

77

78

79. *1931-6 (still life - Greek landscape).*
 Oil and pencil on canvas,
 27 × 30 ½ in. (68.5 × 77.5 cm).
 The British Council.

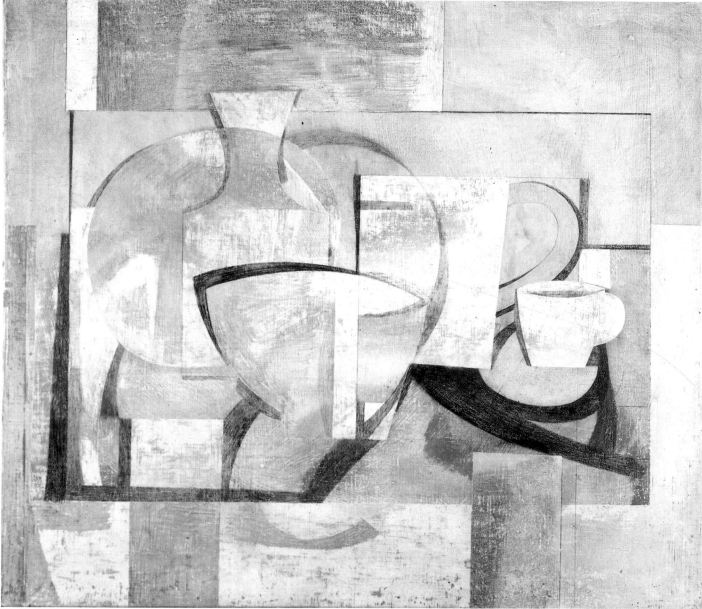

79

80. *1935 (white relief).*
Oil on carved board,
$40 \times 65\,^{1}\!/_{2}$ in. $(101.6 \times 166.4$ cm$)$.
Trustees of the Tate Gallery.

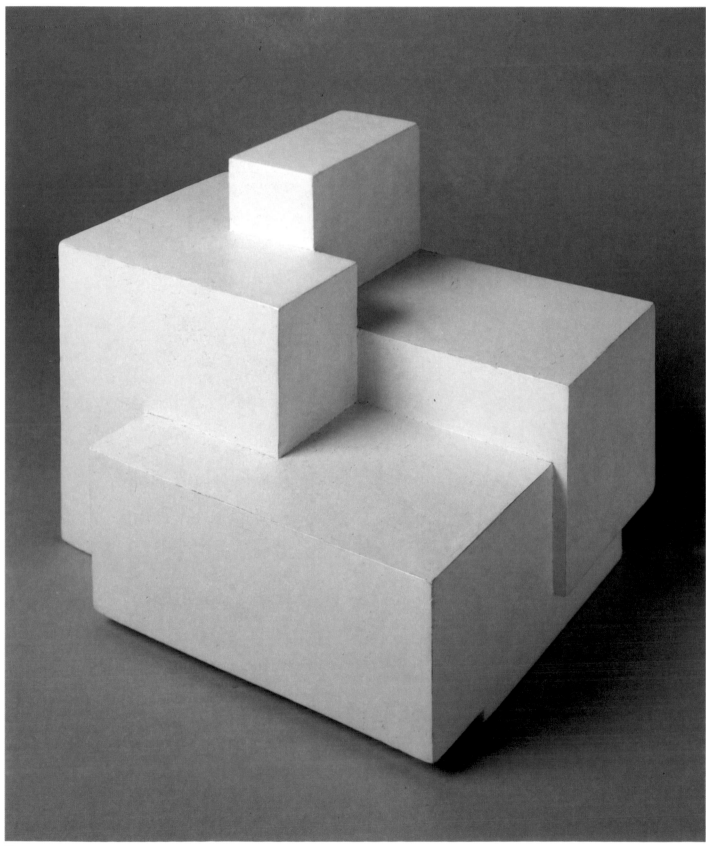

81. *c. 1936 (sculpture)*.
Painted wood,
89 3/4 × 120 × 94 7/8 in. (228 × 305 × 241 cm).
Trustees of the Tate Gallery.

82. *1936 (white relief sculpture version 1)*.
Carved plaster,
7 1/2 × 6 3/4 × 4 1/2 in. (19 × 17.2 × 11.4 cm)
on base 1 3/8 × 8 3/4 × 6 1/4 in. (3.4 × 22.4 × 16 cm).
Private collection.

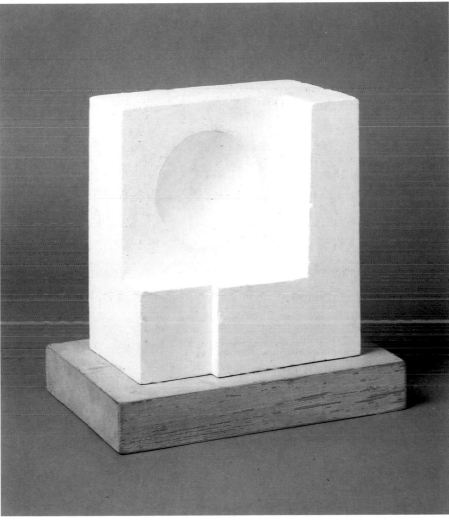

82

83. *1937 (painting).*
Oil on canvas,
19 7/8 × 25 in. (50.6 × 63.5 cm).
Scottish National Gallery of Modern Art.

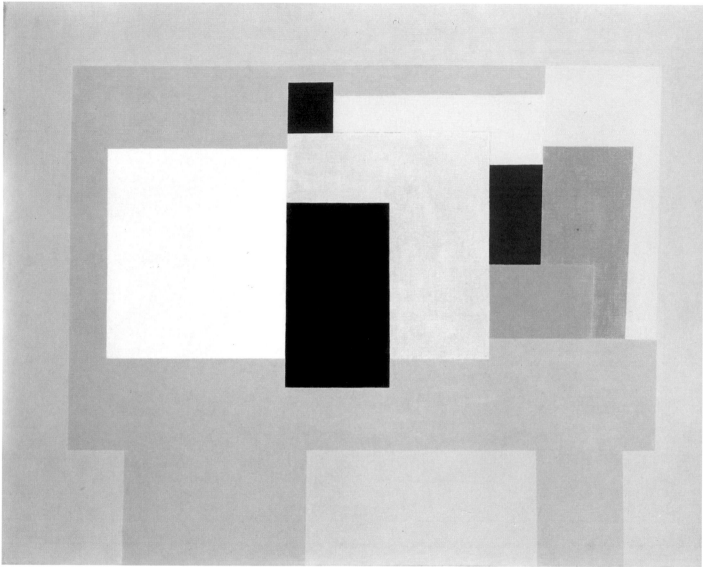

84. *June 1937 (painting)*.
 Oil on canvas,
 62 ¾ × 79 ⅛ in. (159.5 × 201 cm).
 Trustees of the Tate Gallery.

85. *1937 (painting)*.
 Oil on canvas,
 31 ¼ × 36 in. (79.5 × 91.5 cm).
 Courtauld Institute Galleries (Hunter Bequest).

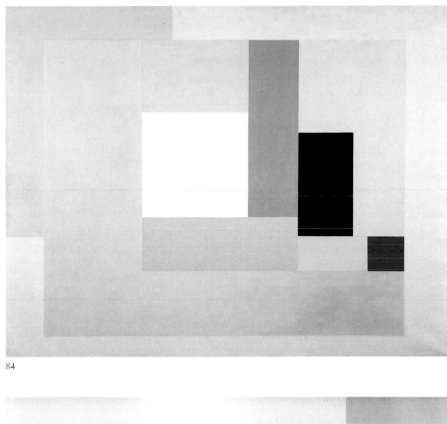

84

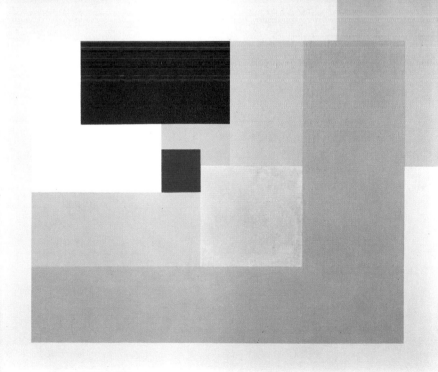

85

86. *c. 1937-8 (white relief).*
Oil on carved board,
25 ¼ × 49 ⅝ in. (64 × 126 cm).
Albright-Knox Art Gallery, Buffalo, New York.
Gift of Seymour H. Knox.

87. *1938 (white relief).*
Oil and pencil on carved board,
41 ¾ × 43 ¼ in. (106 × 110 cm).
Kröller-Müller Museum, Otterlo.

86

87

88. *1938 (white relief - version 1).*
Oil on carved board,
47 ½ × 72 in. (120.5 × 183 cm).
Hirshhorn Museum and Sculpture Garden. Smithsonian
Institution. Gift of Joseph H. Hirshhorn, 1972.

88

89. *1938 (painting - version 1).*
 Oil on canvas,
 $48\,^{5}/_{8} \times 55\,^{1}/_{2}$ in. (123.5 × 141 cm).
 Private collection.

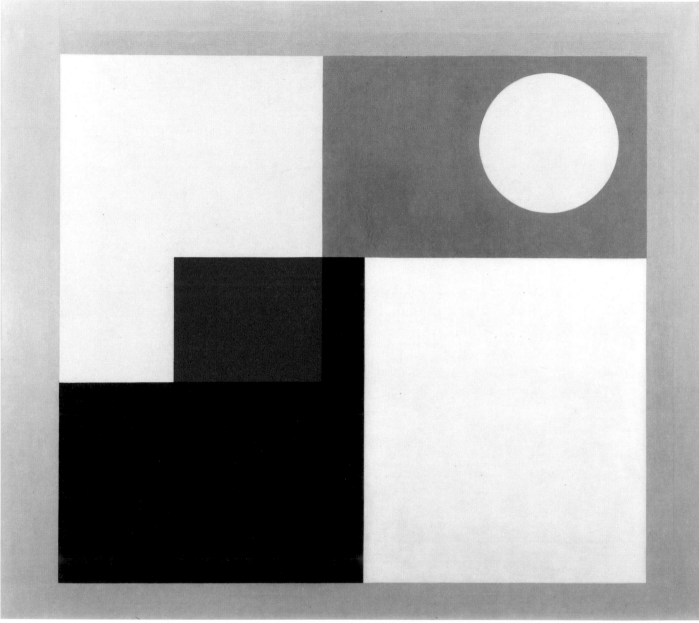

90. *1939 (painted relief - version 1).*
Oil and pencil on carved board,
$32\,^{7}/_{8} \times 45\,^{1}/_{8}$ in. $(83.5 \times 114.5$ cm).
Collection, The Museum of Modern Art, New York.
Gift of H. S. Ede and the artist (by exchange).

91. *1939 (white relief).*
Oil and pencil on carved board,
$30\,^{1}/_{2} \times 29$ in. $(77.5 \times 73.7$ cm).
Private collection.

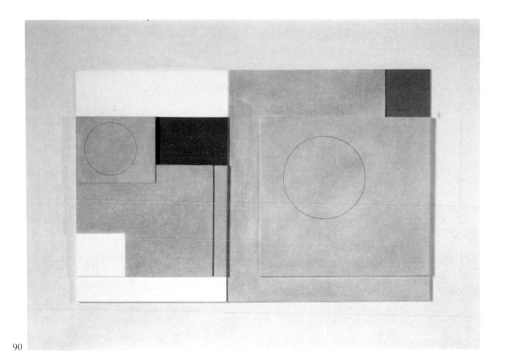

90

91

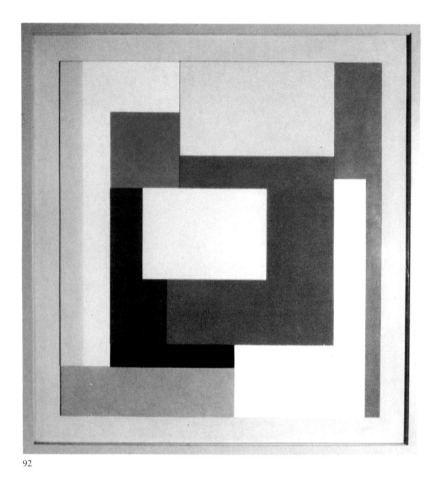

92

92. *1939 (painted relief).*
Oil on carved board,
40⅛ × 38 in. (102 × 96.5 cm).
The Pier Gallery, Stromness, Orkney.

93. *1940 (painting).*
Gouache on board,
24 × 21 in. (60.9 × 53.2 cm).
Leeds City Art Galleries.

94. *1940 (painted relief - version 1).*
Oil on carved board,
20⅝ × 19¾ in. (52.5 × 50 cm).
Private collection.

95. *1932-40 (still life).*
Oil and pencil on canvas,
21¼ × 26⅜ in. (54 × 67 cm).
The Pier Gallery, Stromness, Orkney.

96. *1940 (St Ives).*
Oil on board,
12⅝ × 15⅜ in. (32 × 39 cm).
Private collection.

93

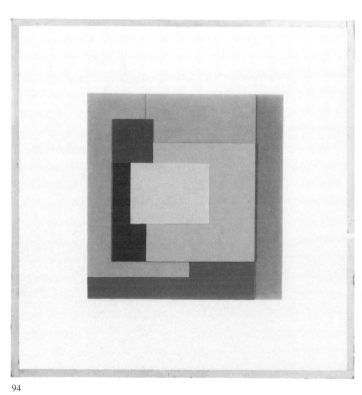

94

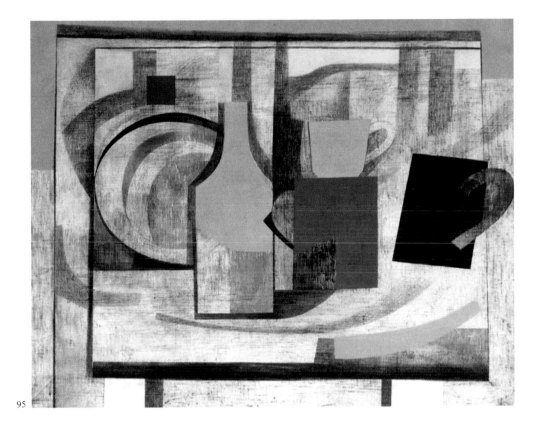

95

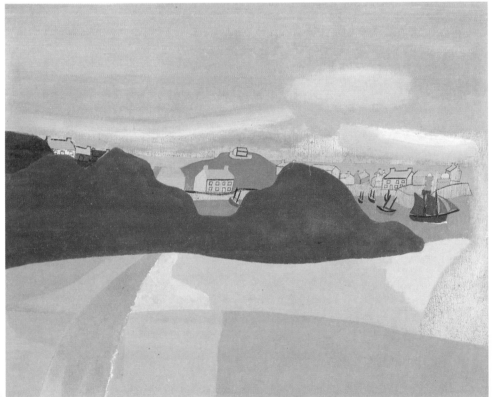

96

97

97. *1941 (painted relief - version 1).*
Oil and pencil on carved board,
26 × 55 ¼ in. (66 × 140.3 cm).
Private collection.

98. *1944-5 (painted relief).*
Oil on carved board,
28 ¾ × 29 ⅛ in. (73 × 74 cm).
The Pier Gallery, Stromness, Orkney.

99. *1940-3 (two forms).*
Oil on canvas mounted on board,
23 ⅞ × 23 ¼ in. (60.5 × 59 cm).
National Museum of Wales.

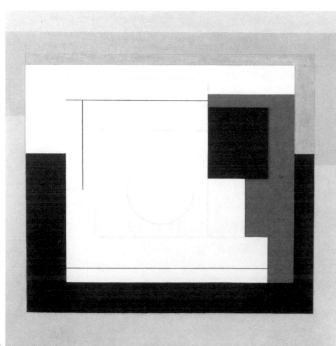

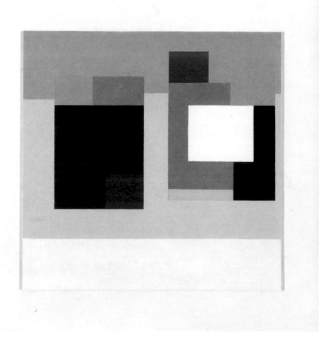

98 99

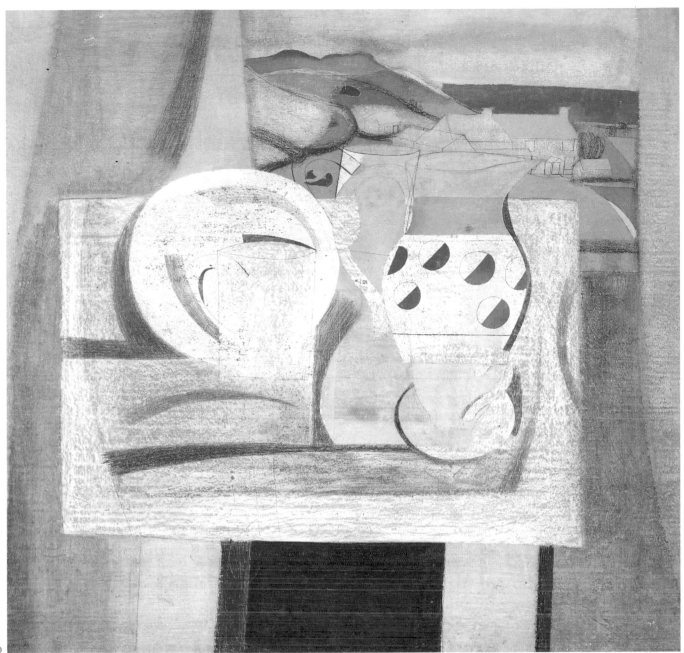

100

100. *1944 (still life and Cornish landscape).*
Oil on board,
31 × 33 in. (78.7 × 83.8 cm).
Collection of IBM Gallery of Science and Art.

101. *1944 (three mugs).*
Oil and pencil on board,
6¾ × 8¼ in. (17 × 20.8 cm).
Kettle's Yard, University of Cambridge.

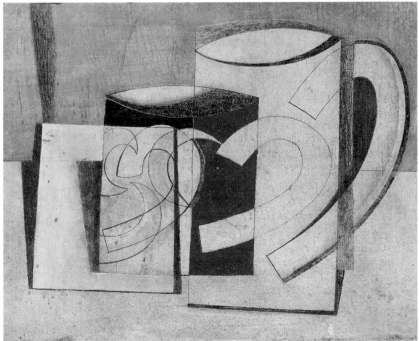

101

102. *1945 (parrot's eye).*
 Oil and pencil on carved board,
 7 ½ × 9 ½ in. (19 × 24 cm).
 Private collection.

103. *1945 (two circles).*
 Oil on canvas mounted on board,
 18 ⅛ × 19 ⅛ in. (46 × 48.5 cm).
 The Pier Gallery, Stromness, Orkney.

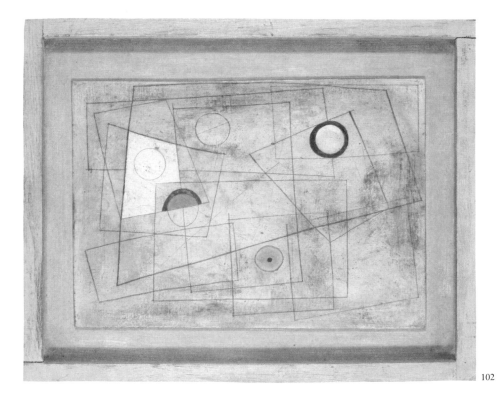

102

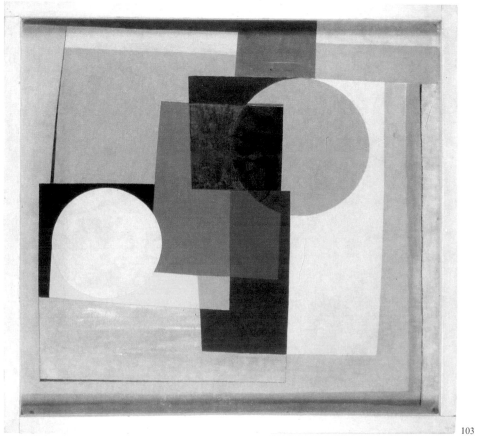

103

104. *July 22 - 47 (still life - Odyssey 1). 1947.*
 Oil on canvas,
 27 ⅛ × 22 in. (69 × 56 cm).
 The British Council.

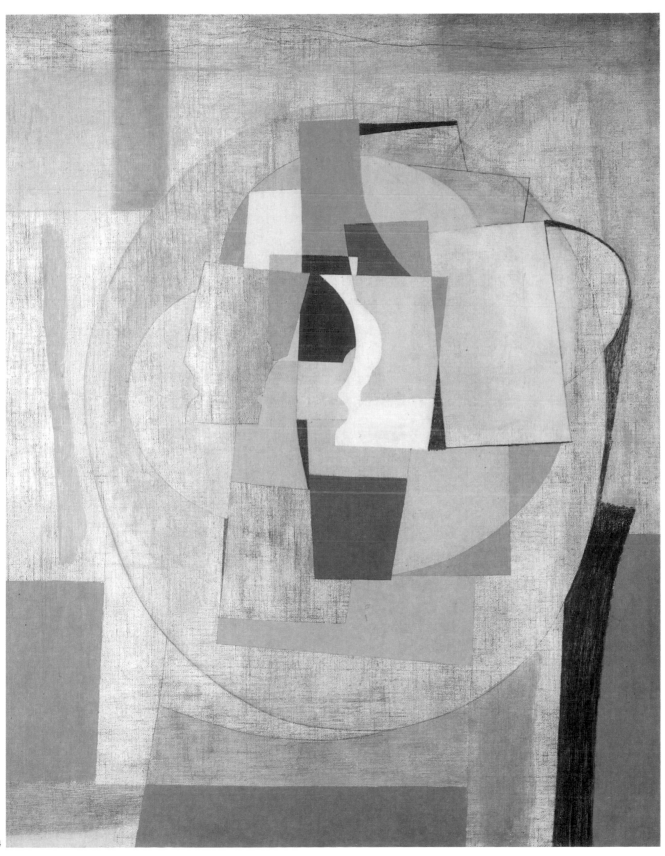

105. *1945 (still life).*
Oil on canvas mounted on board,
27 × 27 in. (68.5 × 68.5 cm).
Albright-Knox Art Gallery, Buffalo, New York.
Room of Contemporary Art Fund.

106. *14 March 1947 (still life - spotted curtain).*
Oil on board,
23 ½ × 25 ¼ in. (59.7 × 64 cm).
Aberdeen Art Gallery.

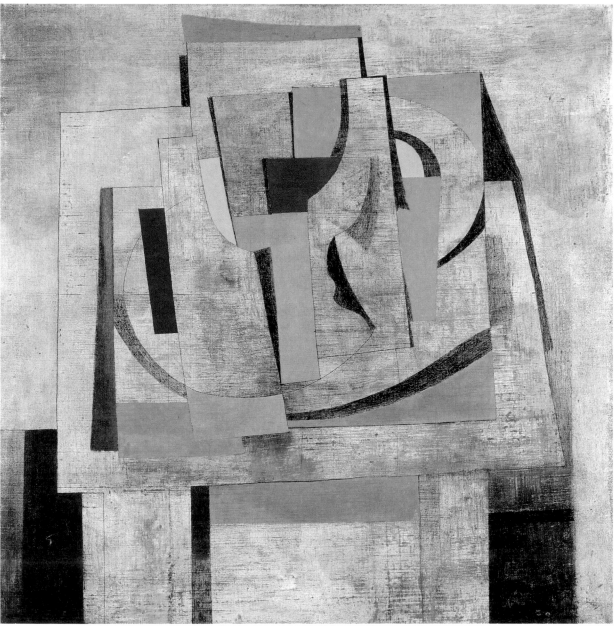

105

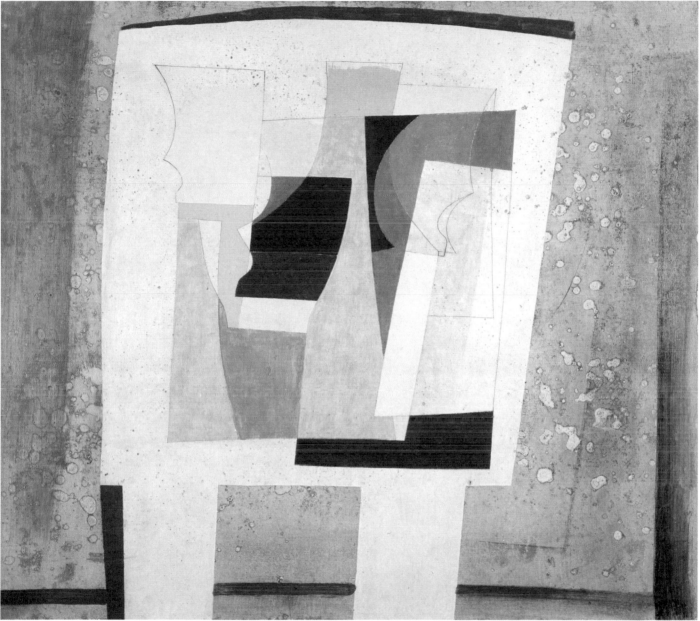

106

107. *November 11 - 47 (Mousehole). 1947.*
Oil and pencil on canvas mounted on board,
18 ¼ × 23 in. (46.5 × 58.5 cm).
The British Council.

108. *December 13 - 47 (Trendrine 2) 1947.*
Oil on canvas,
15 × 14 ⅝ in. (38 × 37 cm).
Phillips Collection, Washington D.C.

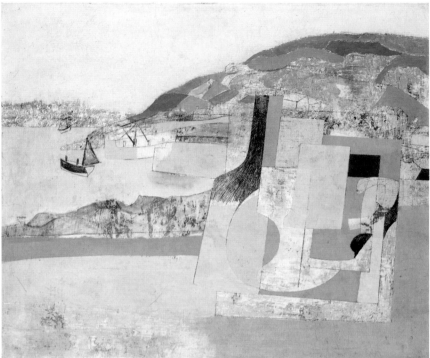

107

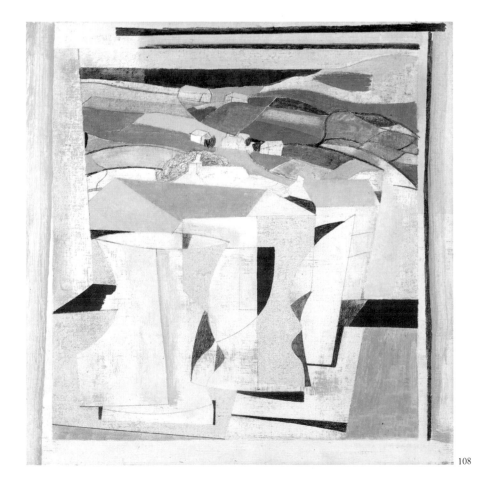

108

109. *December 1949 (poisonous yellow).*
 Oil on canvas,
 49×64 in. (124.4×162.5 cm).
 Museo d'Arte Moderna di Ca'Pesaro, Venice.

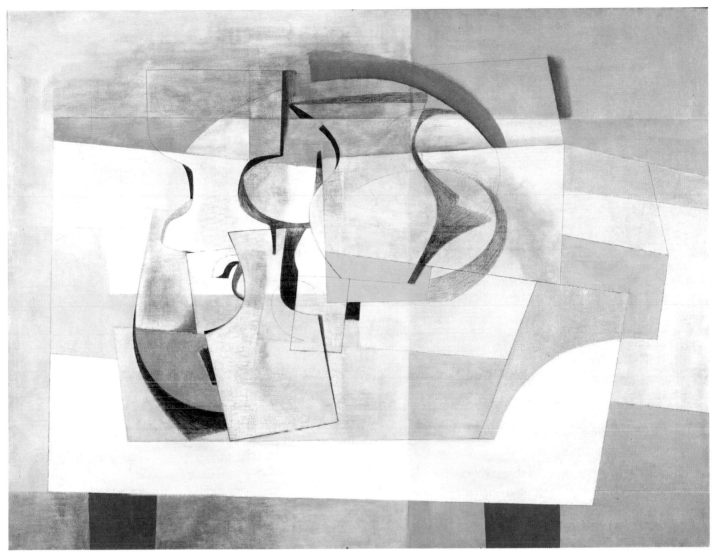

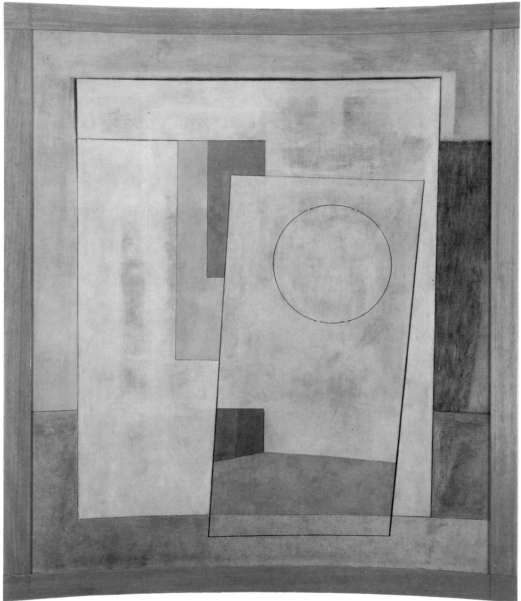

110

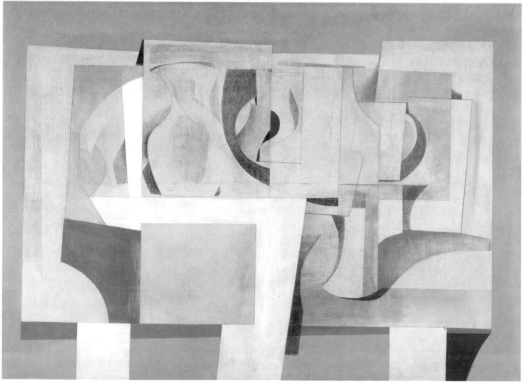

111

110. *October 1949 (Rangitane) curved panel.*
Oil on board,
75 ⅝ × 64 ⅝ in. (192 × 164 cm).
Gimpel Fils, London.

111. *April 1950 (Abélard and Héloise).*
Oil on canvas,
47 ⅛ × 65 ⅛ in. (119.7 × 165.4 cm).
National Gallery of Canada, Ottawa.

112. *March 1949 (Trencrom).*
Oil and pencil on canvas,
43 × 31 ⅛ in. (109 × 79 cm).
The British Council.

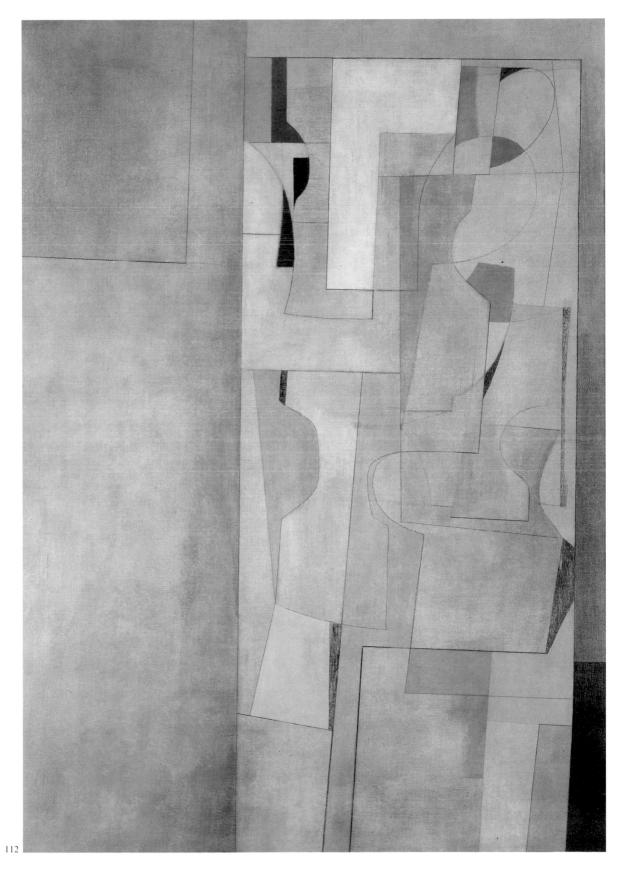

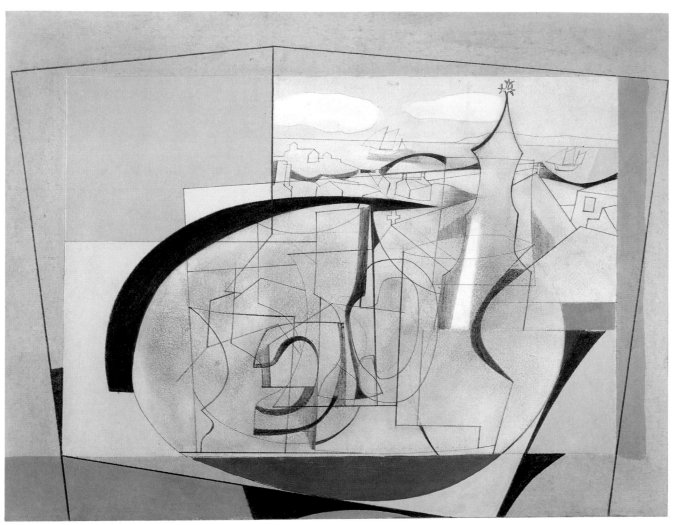

113

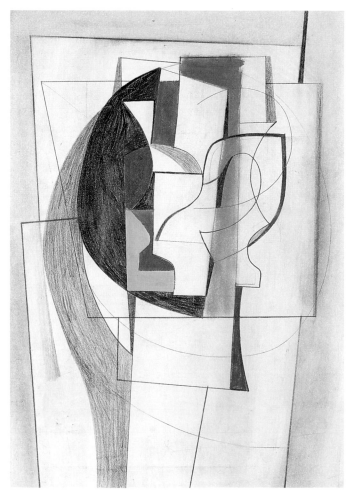

114

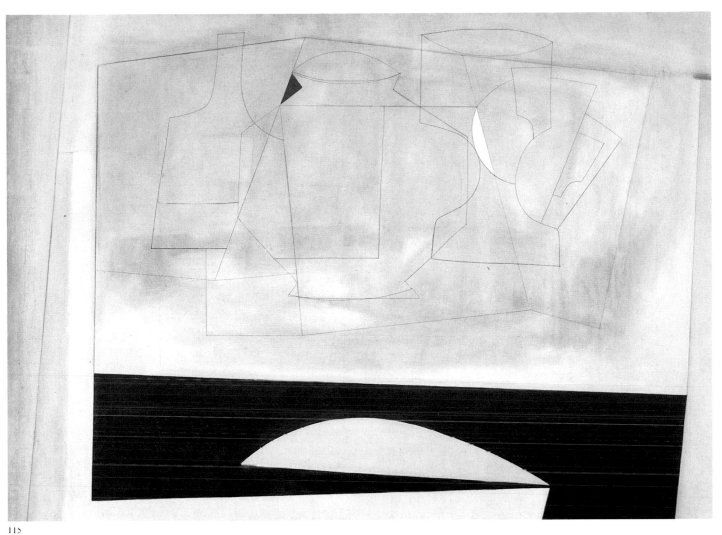

115

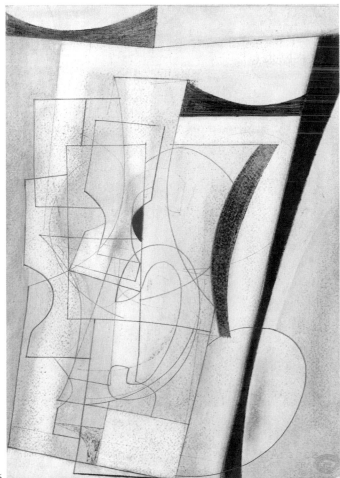

113. *December 1951 (St Ives - oval and steeple).*
Oil and pencil on board mounted on board,
19³/₄ × 26 in. (50 × 66 cm).
City of Bristol Museum and Art Gallery.

114. *November 20 1951 (still life - elevated forms).*
Pencil, gouache and coloured chalks on paper,
19³/₄ × 13³/₈ in. (49 × 34 cm).
Bernard Jacobson Gallery, London.

115. *December 1951 (opal, magenta and black).*
Oil on canvas,
45⁵/₈ × 63³/₈ in. (116 × 161 cm).
Museu do Arte Moderna, Rio de Janeiro.

116. *Nov. 51 (still life - seven). 1951.*
Oil, gouache and pencil on board,
20¹/₈ × 14⁵/₈ in. (51 × 37 cm).
Private collection.

116

117. *Feb. 28 - 53 (vertical seconds) 1953.*
 Oil on canvas,
 29 ³/₄ × 16 ½ in. (75.6 × 41.9 cm).
 Trustees of the Tate Gallery.

118. *March 1953 (Lucca).*
 Oil and pencil on card,
 17 ½ × 14 in. (44.5 × 35.5 cm).
 Musée royaux des Beaux-Arts, Belgium.

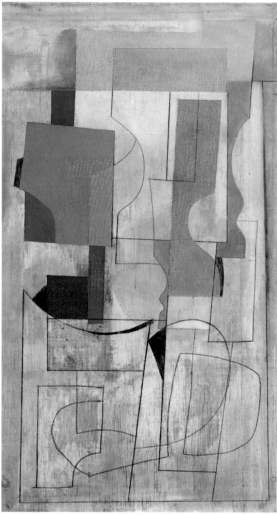

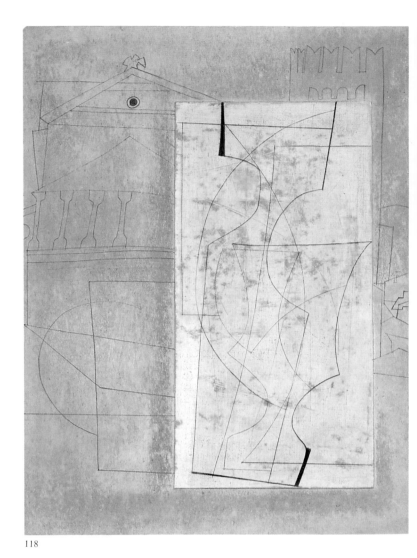

117

118

119. *June 4 - 52 (tableform) 1952.*
 Oil on canvas,
 62½ × 44¾ in. (158.8 × 113.7 cm).
 Albright-Knox Art Gallery, Buffalo, New York.
 Gift of Seymour H. Knox.

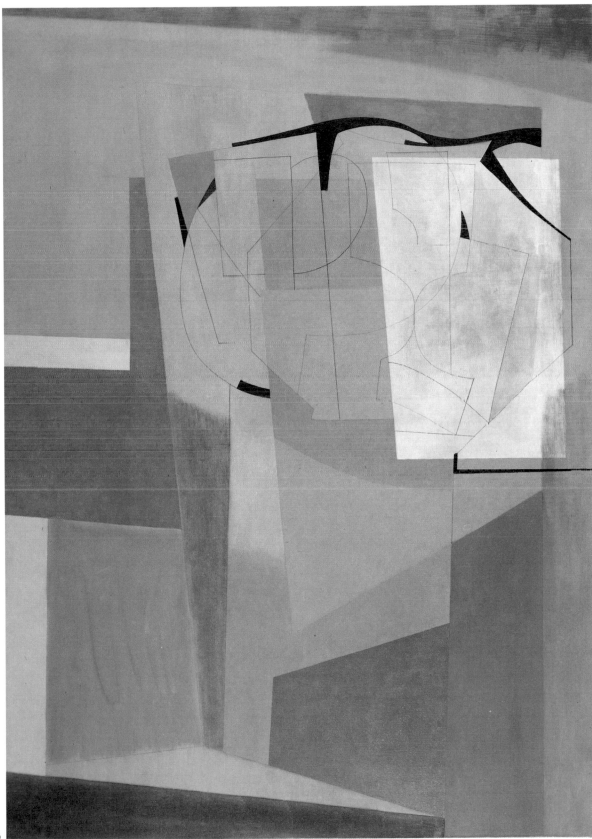

120. *July 1953 (Cyclades).*
 Oil and pencil on curved panel,
 30 × 48 in. (76 × 122 cm).
 Private collection.

121. *February 1953 (contrapuntal).*
 Oil on board,
 66 × 48 in. (167.6 × 121.9 cm).
 Arts Council of Great Britain.

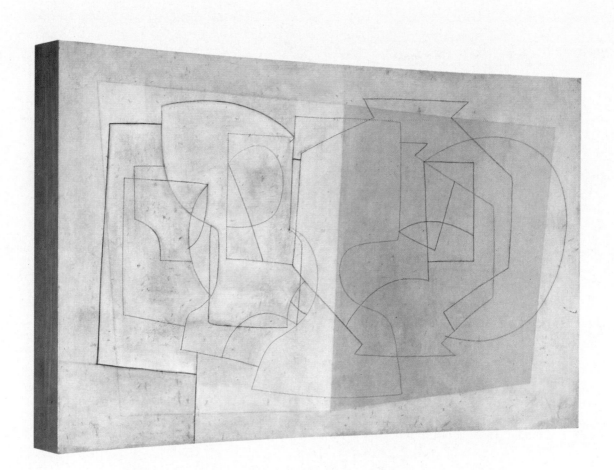

120

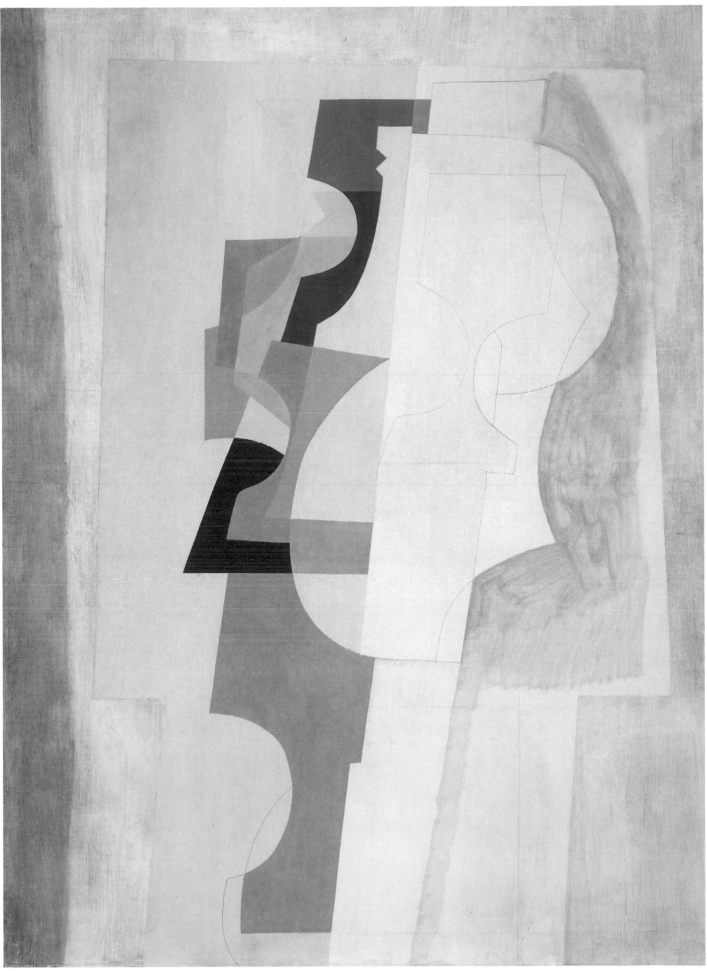

122. *September 1953 (Balearic).*
Oil on canvas,
43 × 47 ¼ in. (109 × 120 cm).
Gimpel Fils, London.

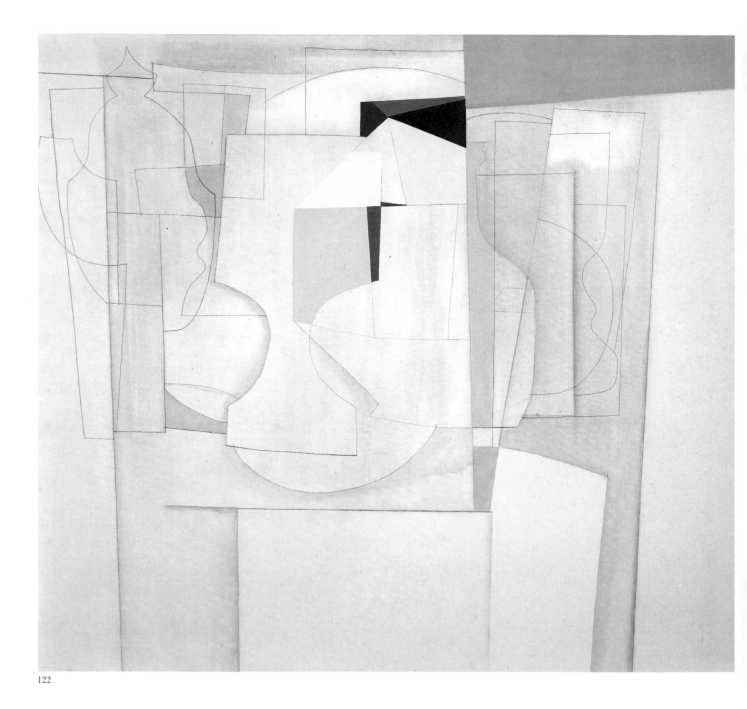

123. *December 1955 (night façade).*
Oil on board,
42 ½ × 45 ¾ in. (108 × 116 cm).
The Solomon R. Guggenheim Museum, New York.

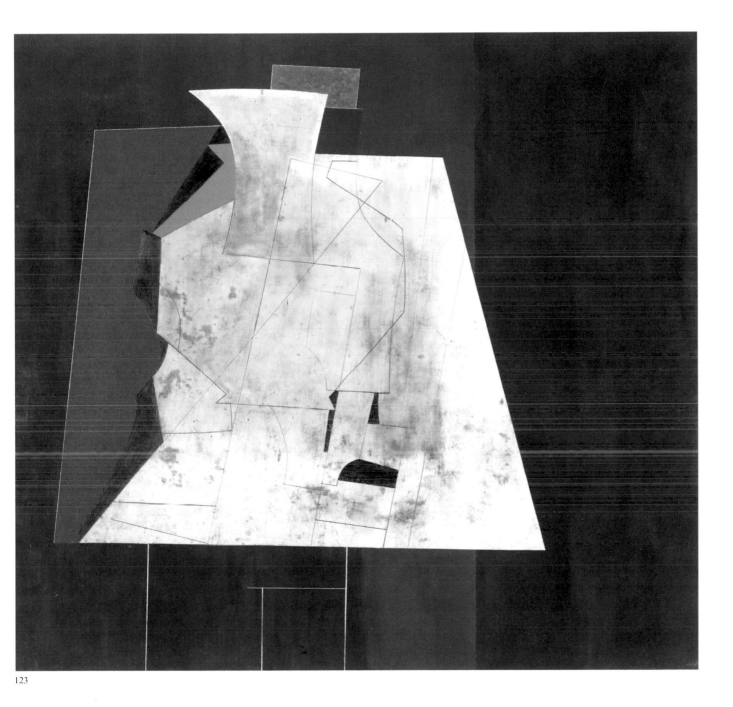

123

124. *1956 (boutique fantastique).*
Oil, gesso and pencil on board,
48 × 84 in. (122 × 213.5 cm).
Private collection.

125. *November 1957 (yellow Trevose).*
Oil and pencil on canvas,
75 × 26¾ in. (190.5 × 68 cm).
Kunsthaus Zürich, Vereinigung Zürcher Kunstfreude.

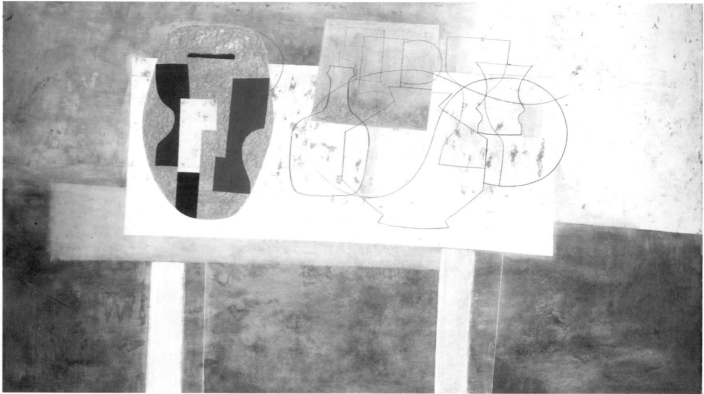

124

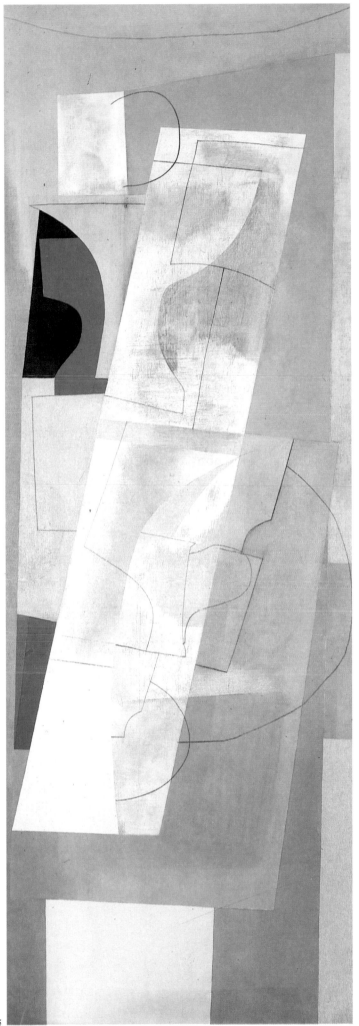

126. *August 1956 (Val d'Orcia).*
 Oil, gesso and pencil on board,
 48×84 in. (122×213.5 cm).
 Trustees of the Tate Gallery.

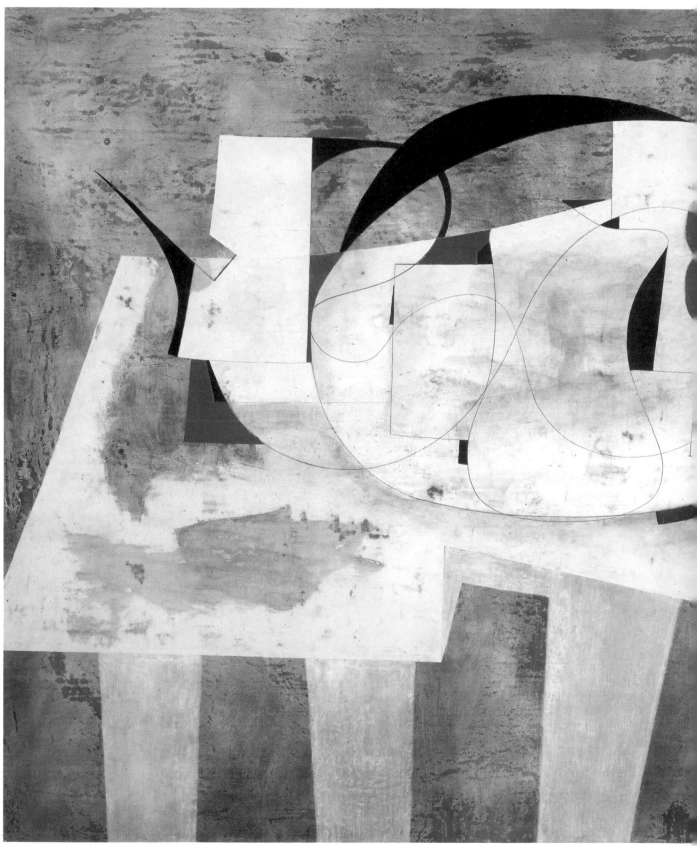

126

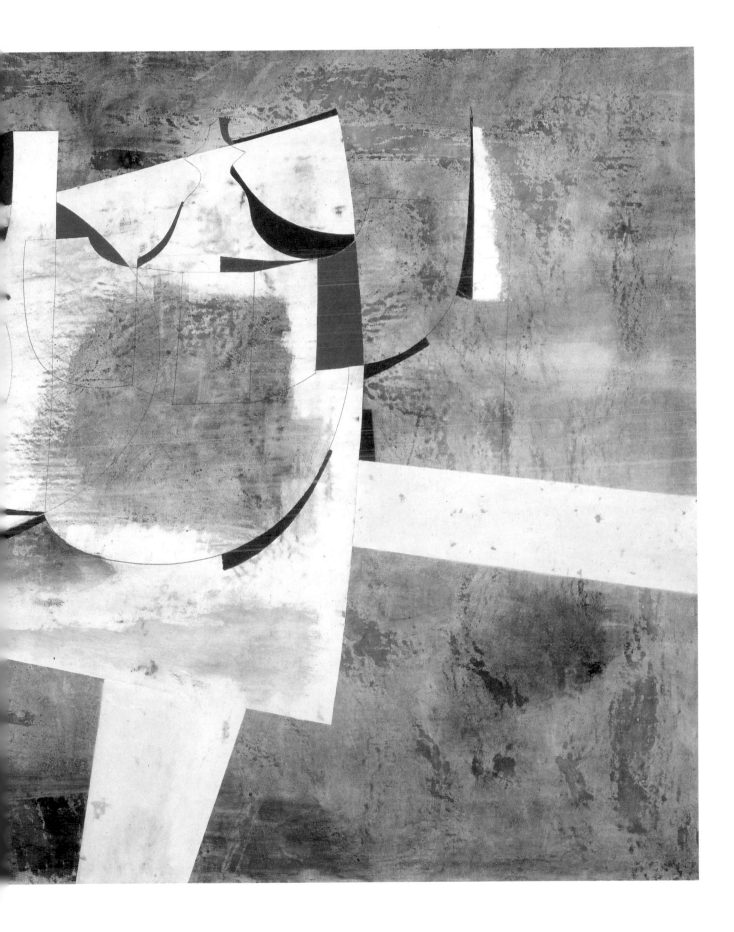

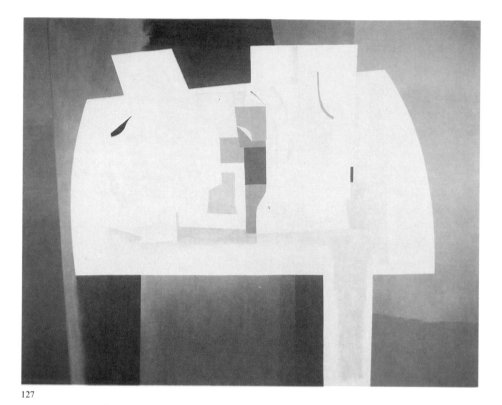

127

127. *1956 (Crete).*
 Oil and pencil on canvas,
 80 × 100 in. (203 × 254 cm).
 Private collection, Lausanne.

128. *1959 (Argolis).*
 Oil, gesso and pencil on board,
 48 × 90 ½ in. (122 × 230 cm).
 Private collection.

129. *February 1960 (ice - off - blue).*
 Oil on carved board,
 48 × 72 ½ in. (122 × 184 cm).
 Trustees of the Tate Gallery.

130. *July 1962 (Mycenae stone).*
 Oil on canvas,
 81 ⅞ × 90 ¼ in. (207.8 × 229.2 cm).
 Private collection, London.

128

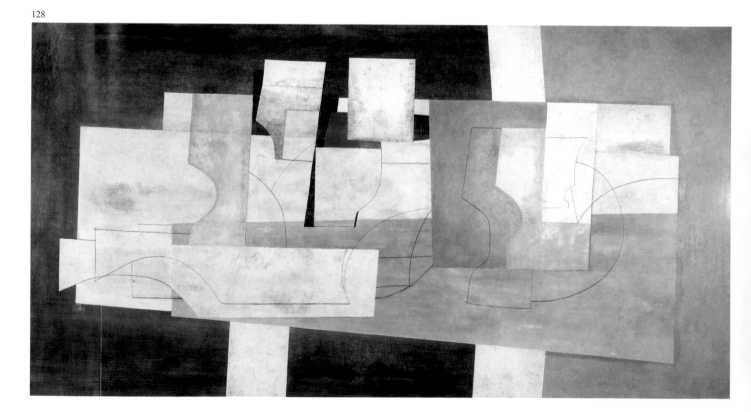

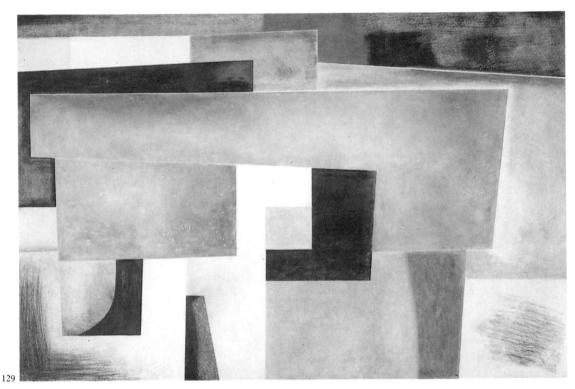

129

130

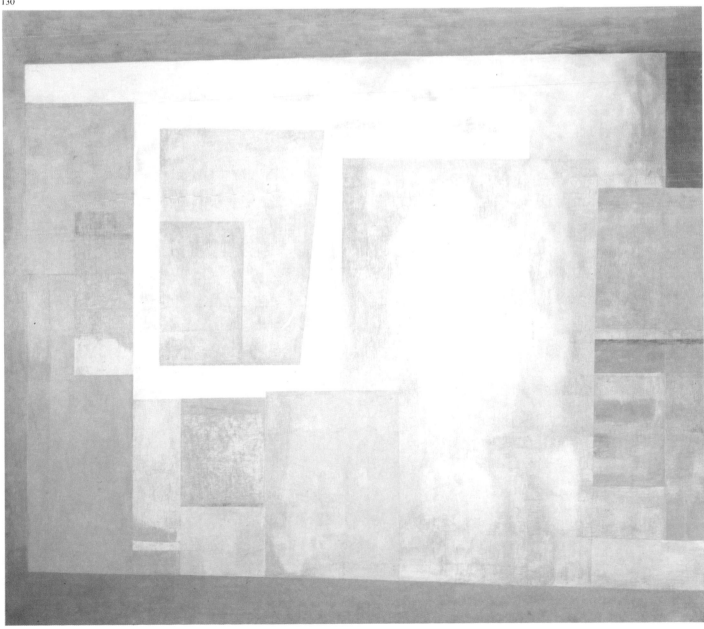

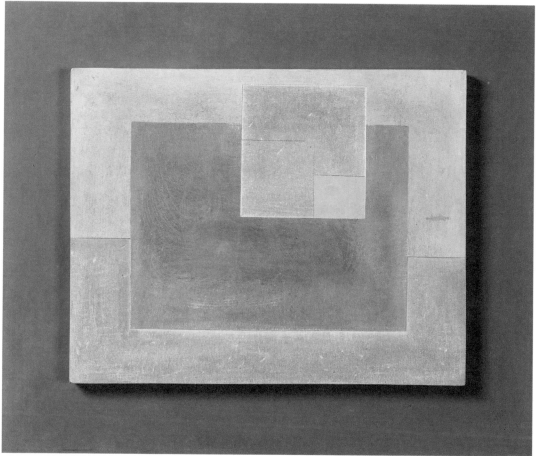

131

131. *1963 (Argos).*
Oil and pencil on carved board mounted on wood,
13⅞ × 17⅝ in. (35.2 × 44.8 cm) on wood, 20⅛ × 23⅝ in. (51 × 60 cm).
Kettle's Yard, University of Cambridge.

132. *August 1964 (Racciano).*
Oil on carved board,
54⅜ × 31¼ in. (138 × 79.5 cm).
The British Council.

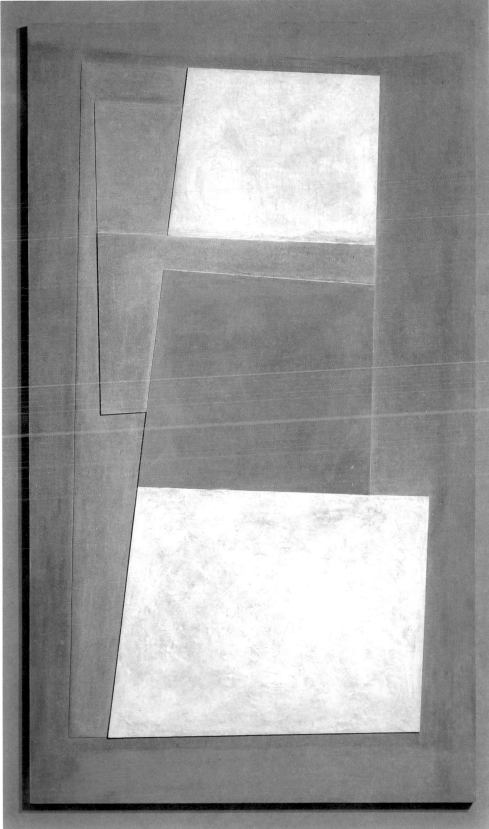

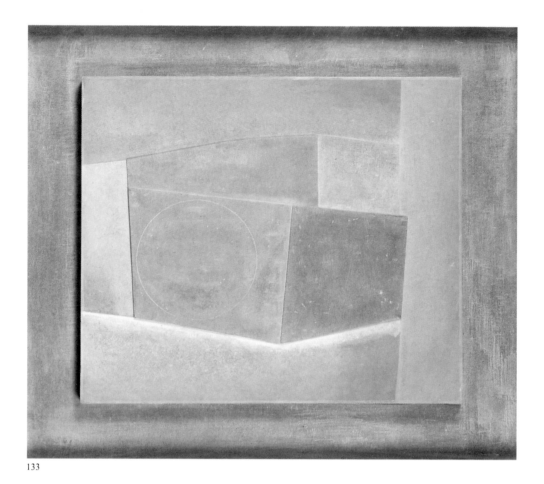

133

133. *June 1964 (valley between Rimini and Urbino).*
Oil on carved board,
24 × 27 ½ in. (61 × 69.9 cm).
The Hakone Open-Air Museum, Japan.

134. *1966 (Erymanthos).*
Oil on carved board,
47 ¾ × 73 in. (121.2 × 185.4 cm).
Waddington Galleries Limited, London.

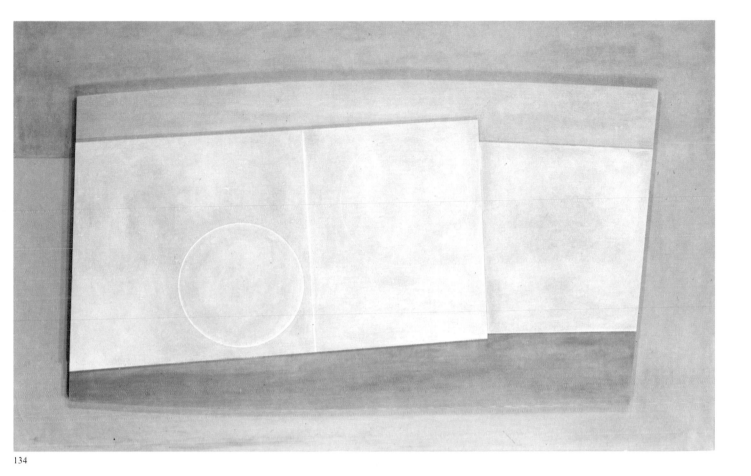

134

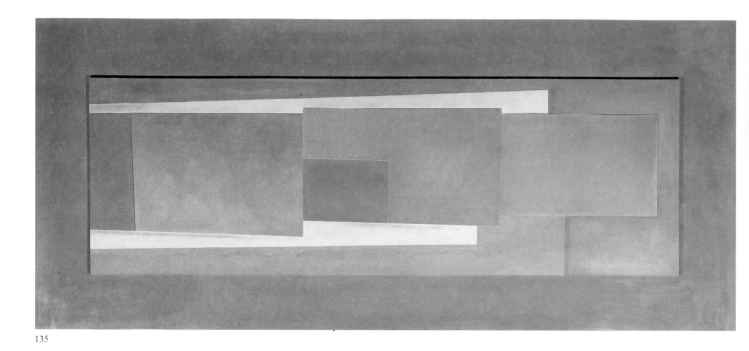

135

135. *1966 (Zennor Quoit 2).*
Oil on carved board,
46 × 102 ¾ in. (116.8 × 261 cm).
The Phillips Collection, Washington, D.C.

136. *1966 (Carnac, red and brown).*
Oil on carved board,
40 × 81 ⅛ in. (101.5 × 206 cm).
Private collection.

137. *1967 (Tuscan relief).*
Oil on carved board,
58 ¼ × 63 ⅜ in. (148 × 161 cm).
Trustees of the Tate Gallery.

136

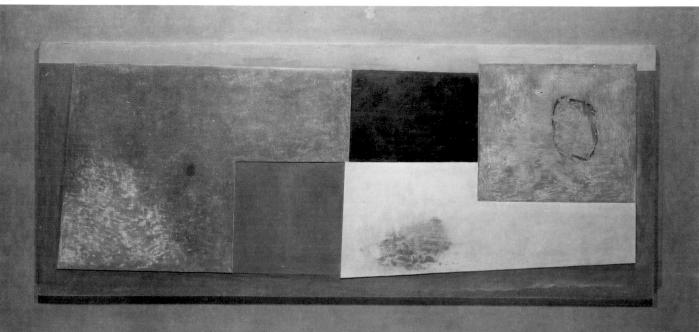

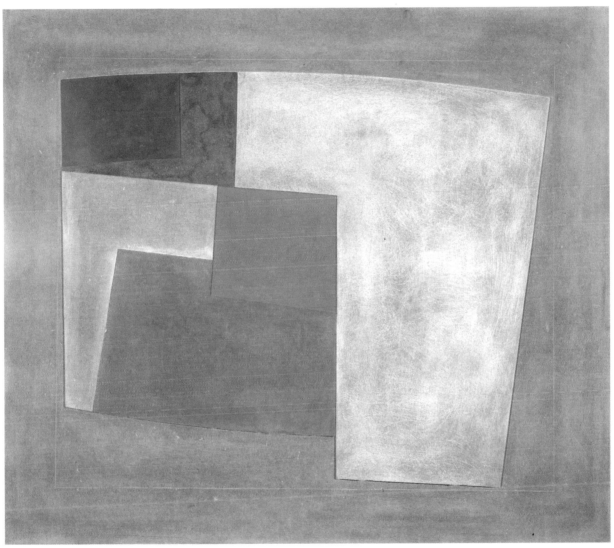

138. *1969 (monolith Carnac 5).*
Oil on carved board,
71 × 42 ⅛ in. (180.3 × 107 cm).
Waddington Galleries Limited, London.

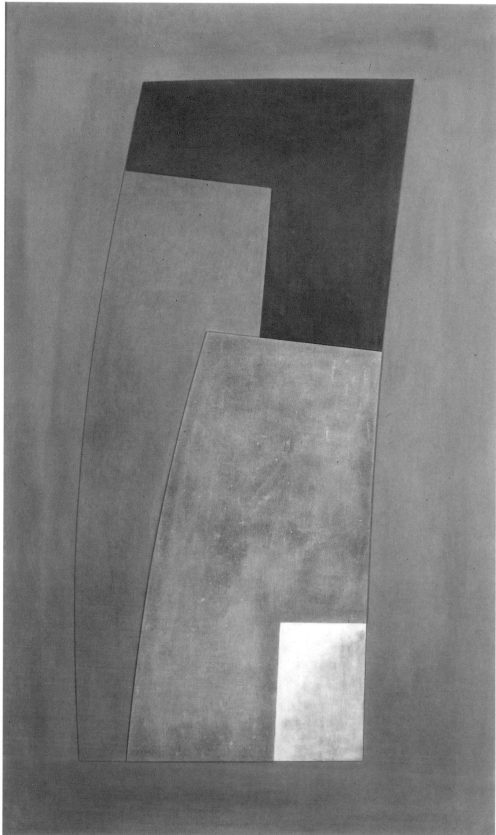

139. *1971 (dolphin).*
 Oil on carved board,
 65 3/8 × 26 3/8 in. (166 × 67 cm).
 The International Art Centre, courtesy Sotheby's.

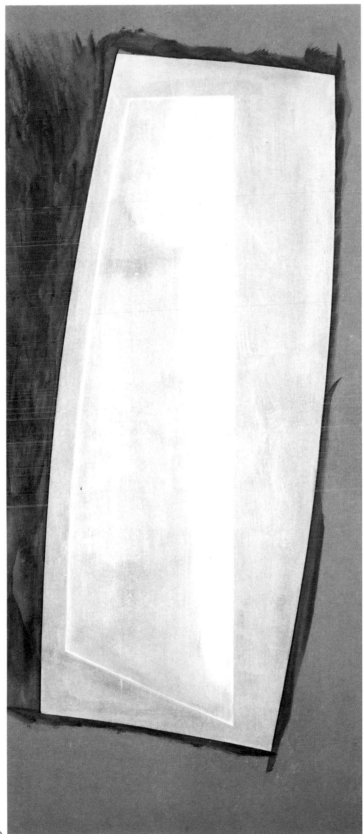

140. *1971 (Obidos, Portugal 3).*
 Oil on carved board,
 51¼×28 in. (130×71.1 cm).
 The International Art Centre, courtesy Sotheby's.

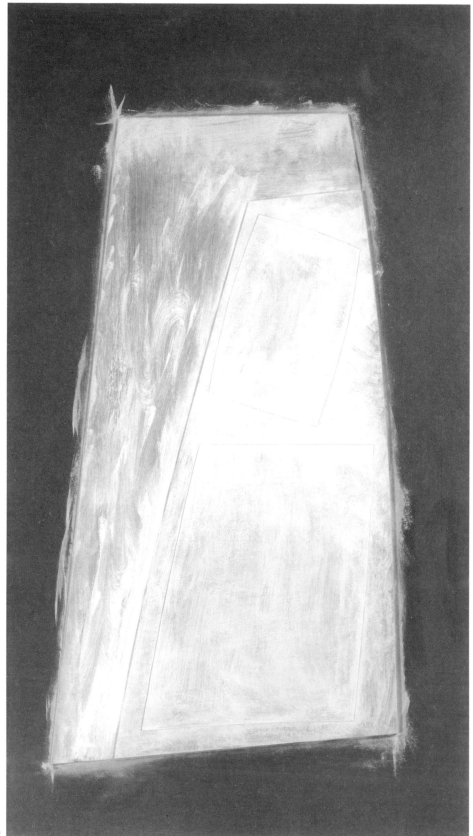

141. *June 1978 (group in movement).*
Pen, oil and wash on paper,
19 3/8 × 21 5/8 in. (49.2 × 54.9 cm).
Private collection, courtesy Waddington Galleries Limited, London.

142. *1979 (vertical stripe).*
Oil and ink on board,
28 3/4 × 21 3/4 in. (73 × 55.3 cm).
Trustees of the Tate Gallery.

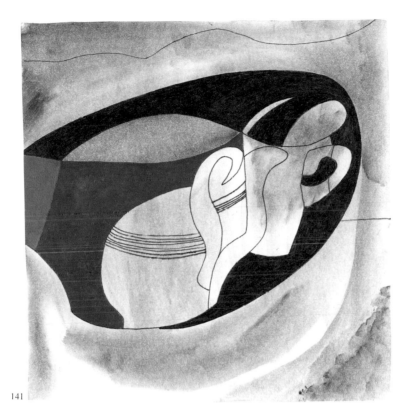

141

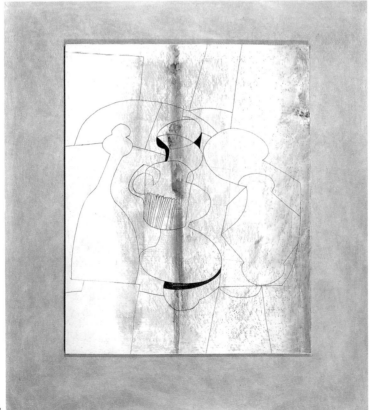

142

LIST OF ILLUSTRATIONS

53. *1933 (girl at mirror).*
Oil and gesso on canvas mounted on
board,
27 × 22 in. (68.6 × 55.9 cm).
Private collection.

54. *1933 (guitar).*
Oil and gesso on canvas,
26 ³/₈ × 21 ¹/₈ in. (67 × 53.7 cm).
Kettle's Yard, University of Cambridge.

55. *1933 (milk and plain chocolate).*
Oil and gesso on board,
53 ¹/₈ × 32 ¹/₄ in. (135 × 82 cm).
Private collection.

56. *1933 (guitar).*
Oil on panel mounted on board,
32 ⁵/₈ × 4 ¹/₈ in. (83 × 10.5 cm)
on board 35 ¹/₄ × 9 ⁷/₈ in. (89.5 × 25 cm).
Trustees of the Tate Gallery.

57. *1933 (collage with Spanish postcard).*
Oil and pencil with collage of paper
and printed fabric on canvas,
19 ³/₄ × 29 ¹/₂ in. (50 × 75 cm).
Ivor Braka Limited, London.

58. *1933 (composition in black and white).*
Oil and gesso on board,
45 × 22 in. (114.3 × 55.9 cm).
Borough of Thamesdown - Swindon
Permanent Art Collection.

59. *1933 (composition - hibiscus).*
Oil and gesso on canvas,
52 × 21 ⁷/₈ in. (132 × 55.5 cm).
Ohara Museum of Art, Kurashiki, Japan.

60. *1933 (painted relief).*
Oil on carved board,
17 ³/₈ × 11 ³/₈ in. (44 × 29 cm).
Private collection.

61. *1933 (six circles).*
Oil on carved board,
45 × 22 in. (114.5 × 56 cm).
Private collection.

62. *1933 (red and lilac circle).*
Oil and pencil on board,
23 ¹/₄ × 10 in. (59 × 25.5 cm).
Ivor Braka Limited, London

63. *1934 (painted relief).*
Oil and pencil on carved board,
6 ¹/₈ × 6 ¹/₂ in. (15.5 × 16.5 cm).
Private collection.

64. *1934 (relief).*
Oil on carved board,
4 × 4 in. (10 × 10 cm).
Kettle's Yard, University of Cambridge.

65. *Christmas 1933 (relief box).*
Oil on wood,
3 ¹/₈ × 4 × 2 in. (8 × 10 × 5.2 cm).
Private collection.

66. *c. 1933 (bus ticket).*
Oil and pencil on board,
⁵/₈ × 5 ⁷/₈ in. (1.5 × 14.8 cm).
Private collection.

67. *1934 (relief).*
Oil on carved board,
28 ¹/₄ × 38 in. (71.8 × 96.5 cm).
Trustees of the Tate Gallery.

68. *1934 (painting).*
Oil on canvas,
28 ³/₈ × 39 ³/₄ in. (72 × 101 cm).
Kunstmuseum Düsseldorf.

69. *1934 (painting).*
Oil on board,
14 ⁵/₈ × 17 ³/₄ in. (37 × 45 cm).
The Pier Gallery, Stromness, Orkney.

70. *1934 (white relief).*
Oil on carved board,
21 ¹/₂ × 31 ⁷/₈ in. (54.5 × 81 cm).
Ivor Braka Limited, London.

71. *1934 (still life, Birdie).*
Oil on canvas,
18 ¹/₈ × 24 in. (46 × 61 cm).
York City Art Gallery.

72. *1934-6 (painting - still life).*
Oil and gesso on canvas,
16 ¹/₈ × 19 ⁷/₈ in. (41 × 50.6 cm).
Private collection.

73. *1934 (Florentine ballet).*
Oil and pencil on canvas,
13 ³/₄ × 23 ¹/₄ in. (35 × 59 cm).
Private collection.

74. *1933-5 (still life with bottle and mugs).*
Oil and gesso on board,
19 ¹/₂ × 23 ³/₈ in. (49.5 × 59.5 cm).
Helen Sutherland Collection.

75. *1934 (white relief).*
Oil on canvas,
13 ³/₄ × 24 in. (34.9 × 61 cm).
Private collection.

76. *1935 (painting).*
Oil on canvas,
23 ⁵/₈ × 35 ⁷/₈ in. (60 × 91 cm).
Private collection.

77. *1935 (white relief).*
Oil on board,
21 ³/₈ × 25 ¹/₄ in. (54.4 × 64.2 cm).
Scottish National Gallery of Modern Art.

78. *1935 (painting).*
Oil on canvas,
40 × 41 ¹/₂ in. (101.6 × 105.4 cm).
Private collection.

79. *1931-6 (still life - Greek landscape).*
Oil and pencil on canvas,
27 × 30 ¹/₂ in. (68.5 × 77.5 cm).
The British Council.

80. *1935 (white relief).*
Oil on carved board,
40 × 65 ¹/₂ in. (101.6 × 166.4 cm).
Trustees of the Tate Gallery.

81. *c. 1936 (sculpture).*
Painted wood,
89 ¹/₄ × 120 × 94 ⁷/₈ in. (228 × 305 × 241 cm).
Trustees of the Tate Gallery.

82. *1936 (white relief sculpture version 1).*
Carved plaster,
7 ¹/₂ × 6 ³/₄ × 4 ¹/₂ in. (19 × 17.2 × 11.4 cm)
on base 1 ³/₈ × 8 ³/₄ × 6 ¹/₄ in.
(3.4 × 22.4 × 16 cm).
Private collection.

83. *1937 (painting).*
Oil on canvas,
19 ⁷/₈ × 25 in. (50.6 × 63.5 cm).
Scottish National Gallery of Modern Art.

84. *June 1937 (painting).*
Oil on canvas,
62 ³/₄ × 79 ¹/₈ in. (159.5 × 201 cm).
Trustees of the Tate Gallery.

85. *1937 (painting).*
Oil on canvas,
31 ¹/₄ × 36 in. (79.5 × 91.5 cm).
Courtauld Institute Galleries (Hunter
Bequest).

86. *c. 1937-8 (white relief).*
Oil on carved board,
25 ¹/₄ × 49 ⁵/₈ in. (64 × 126 cm).
Albright-Knox Art Gallery, Buffalo,
New York. Gift of Seymour H. Knox.

87. *1938 (white relief).*
Oil and pencil on carved board,
41 ³/₄ × 43 ¹/₄ in. (106 × 110 cm).
Kröller-Müller Museum, Otterlo.

88. *1938 (white relief - version 1).*
Oil on carved board,
47 ¹/₂ × 72 in. (120.5 × 183 cm).
Hirshhorn Museum and Sculpture
Garden. Smithsonian Institution. Gift
of Joseph H. Hirshhorn, 1972.

89. *1938 (painting - version 1).*
Oil on canvas,
48 ⁵/₈ × 55 ¹/₂ in. (123.5 × 141 cm).
Private collection.

90. *1939 (painted relief - version 1).*
Oil and pencil on carved board,
32 ⁷/₈ × 45 ¹/₈ in. (83.5 × 114.5 cm).
Collection, The Museum of Modern
Art, New York.
Gift of H. S. Ede and the artist (by
exchange).

91. *1939 (white relief).*
Oil and pencil on carved board,
30 ¹/₂ × 29 in. (77.5 × 73.7 cm).
Private collection.

92. *1939 (painted relief).*
Oil on carved board,
40 ¹/₈ × 38 in. (102 × 96.5 cm).
The Pier Gallery, Stromness, Orkney.

93. *1940 (painting).*
Gouache on board,
24 × 21 in. (60.9 × 53.2 cm).
Leeds City Art Galleries.

94. *1940 (painted relief - version 1).*
Oil on carved board,
20 ⁵/₈ × 19 ¹/₄ in. (52.5 × 50 cm).
Private collection.

95. *1932-40 (still life).*
Oil and pencil on canvas,
21 ¹/₄ × 26 ³/₈ in. (54 × 67 cm).
The Pier Gallery, Stromness, Orkney.

96. *1940 (St Ives).*
Oil on board,
12 ⁵/₈ × 15 ³/₈ in. (32 × 39 cm).
Private collection.

97. *1941 (painted relief - version 1).*
Oil and pencil on carved board,
26 × 55 ¹/₄ in. (66 × 140.3 cm).
Private collection.

98. *1944-5 (painted relief).*
Oil on carved board,
28 ³/₄ × 29 ¹/₈ in. (73 × 74 cm).
The Pier Gallery, Stromness, Orkney.

99. *1940-3 (two forms).*
Oil on canvas mounted on board,
23 ⁷/₈ × 23 ¹/₄ in. (60.5 × 59 cm).
National Museum of Wales.

100. *1944 (still life and Cornish landscape).*
Oil on board,
31 × 33 in. (78.7 × 83.8 cm).
Collection of IBM Gallery of Science
and Art.

101. *1944 (three mugs).*
Oil and pencil on board,
6 ³/₄ × 8 ¹/₄ in. (17 × 20.8 cm).
Kettle's Yard, University of
Cambridge.

102. *1945 (parrot's eye).*
Oil and pencil on carved board,
7 ¹/₂ × 9 ¹/₂ in. (19 × 24 cm).
Private collection.

103. *1945 (two circles).*
Oil on canvas mounted on board,
18 1/8 × 19 1/8 in. (46 × 48.5 cm).
The Pier Gallery, Stromness, Orkney.

104. *July 22 - 47 (still life - Odyssey 1). 1947.*
Oil on canvas,
27 1/8 × 22 in. (69 × 56 cm).
The British Council.

105. *1945 (still life).*
Oil on canvas mounted on board,
27 × 27 in. (68.5 × 68.5 cm).
Albright-Knox Art Gallery, Buffalo,
New York.
Room of Contemporary Art Fund.

106. *14 March 1947 (still life - spotted curtain).*
Oil on board,
23 1/2 × 25 1/4 in. (59.7 × 64 cm).
Aberdeen Art Gallery.

107. *November 11 - 47 (Mousehole). 1947.*
Oil and pencil on canvas mounted on board,
18 1/4 × 23 in. (46.5 × 58.5 cm).
The British Council.

108. *December 13 - 47 (Trendrine 2) 1947.*
Oil on canvas,
15 × 14 5/8 in. (38 × 37 cm).
Phillips Collection, Washington D.C.

109. *December 1949 (poisonous yellow).*
Oil on canvas,
49 × 64 in. (124.4 × 162.5 cm).
Museo d'Arte Moderna di Ca'Pesaro,
Venice.

110. *October 1949 (Rangitane) curved panel.*
Oil on board,
75 5/8 × 64 5/8 in. (192 × 164 cm).
Gimpel Fils, London.

111. *April 1950 (Abélard and Héloise).*
Oil on canvas,
47 1/8 × 65 1/8 in. (119.7 × 165.4 cm).
National Gallery of Canada, Ottawa.

112. *March 1949 (Trencrom).*
Oil and pencil on canvas,
43 × 31 1/8 in. (109 × 79 cm).
The British Council.

113. *December 1951 (St Ives - oval and steeple).*
Oil and pencil on board mounted on board,
19 3/4 × 26 in. (50 × 66 cm).
City of Bristol Museum and Art Gallery.

114. *November 20 1951 (still life - elevated forms).*
Pencil, gouache and coloured chalks on paper,
19 3/4 × 13 3/8 in. (49 × 34 cm).
Bernard Jacobson Gallery, London.

115. *December 1951 (opal, magenta and black).*
Oil on canvas,
45 5/8 × 63 3/8 in. (116 × 161 cm).
Museu do Arte Moderna, Rio de Janeiro.

116. *Nov. 51 (still life - seven). 1951.*
Oil, gouache and pencil on board,
20 1/8 × 14 5/8 in. (51 × 37 cm).
Private collection.

117. *Feb. 28 - 53 (vertical seconds) 1953.*
Oil on canvas,
29 3/4 × 16 1/2 in. (75.6 × 41.9 cm).
Trustees of the Tate Gallery.

118. *March 1953 (Lucca).*
Oil and pencil on card,
17 1/2 × 14 in. (44.5 × 35.5 cm).
Musée royaux des Beaux-Arts,
Belgium.

119. *June 4 - 52 (tableform) 1952.*
Oil on canvas,
62 1/2 × 44 3/4 in. (158.8 × 113.7 cm).
Albright-Knox Art Gallery, Buffalo,
New York.
Gift of Seymour H. Knox.

120. *July 1953 (Cyclades).*
Oil and pencil on curved panel,
30 × 48 in. (76 × 122 cm).
Private collection.

121. *February 1953 (contrapuntal).*
Oil on board,
66 × 48 in. (167.6 × 121.9 cm).
Arts Council of Great Britain.

122. *September 1953 (Balearic).*
Oil on canvas,
43 × 47 1/4 in. (109 × 120 cm).
Gimpel Fils, London.

123. *December 1955 (night façade).*
Oil on board,
42 1/2 × 45 3/4 in. (108 × 116 cm).
The Solomon R. Guggenheim
Museum, New York.

124. *1956 (boutique fantastique).*
Oil, gesso and pencil on board,
48 × 84 in. (122 × 213.5 cm).
Private collection.

125. *November 1957 (yellow Trevose).*
Oil and pencil on canvas,
75 × 26 3/4 in. (190.5 × 68 cm).
Kunsthaus Zürich, Vereinigung
Zürcher Kunstfreude.

126. *August 1956 (Val d'Orcia).*
Oil, gesso and pencil on board,
48 × 84 in. (122 × 213.5 cm).
Trustees of the Tate Gallery.

127. *1956 (Crete).*
Oil and pencil on canvas,
80 × 100 in. (203 × 254 cm).
Private collection, Lausanne.

128. *1959 (Argolis).*
Oil, gèsso and pencil on board,
48 × 90 1/2 in. (122 × 230 cm).
Private collection.

129. *February 1960 (ice - off - blue).*
Oil on carved board,
48 × 72 1/2 in. (122 × 184 cm).
Trustees of the Tate Gallery.

130. *July 1962 (Mycenae stone).*
Oil on canvas,
81 7/8 × 90 1/4 in. (207.8 × 229.2 cm).
Private collection, London.

131. *1963 (Argos).*
Oil and pencil on carved board
mounted on wood,
13 7/8 × 17 5/8 in. (35.2 × 44.8 cm) on
wood, 20 1/8 × 23 5/8 in. (51 × 60 cm).
Kettle's Yard, University of
Cambridge.

132. *August 1964 (Racciano).*
Oil on carved board,
54 3/8 × 31 1/4 in. (138 × 79.5 cm).
The British Council.

133. *June 1964 (valley between Rimini and Urbino).*
Oil on carved board,
24 × 27 1/2 in. (61 × 69.9 cm).
The Hakone Open-Air Museum,
Japan.

134. *1966 (Erymanthos).*
Oil on carved board,
47 3/4 × 73 in. (121.2 × 185.4 cm).
Waddington Galleries Limited,
London.

135. *1966 (Zennor Quoit 2).*
Oil on carved board,
46 × 102 3/4 in. (116.8 × 261 cm).
The Phillips Collection, Washington,
D.C.

136. *1966 (Carnac, red and brown).*
Oil on carved board,
40 × 81 1/8 in. (101.5 × 206 cm).
Private collection.

137. *1967 (Tuscan relief).*
Oil on carved board,
58 1/4 × 63 3/8 in. (148 × 161 cm).
Trustees of the Tate Gallery.

138. *1969 (monolith Carnac 5).*
Oil on carved board,
71 × 42 1/8 in. (180.3 × 107 cm).
Waddington Galleries Limited,
London.

139. *1971 (dolphin).*
Oil on carved board,
65 3/8 × 26 3/8 in. (166 × 67 cm).
The International Art Centre, courtesy
Sotheby's.

140. *1971 (Obidos, Portugal 3).*
Oil on carved board,
51 1/4 × 28 in. (130 × 71.1 cm).
The International Art Centre, courtesy
Sotheby's.

141. *June 1978 (group in movement).*
Pen, oil and wash on paper,
19 3/8 × 21 5/8 in. (49.2 × 54.9 cm).
Private collection, courtesy
Waddington Galleries Limited, London.

142. *1979 (vertical stripe).*
Oil and ink on board,
28 3/4 × 21 3/4 in. (73 × 55.3 cm).
Trustees of the Tate Gallery.